DIGITAL CINEMA

QUICK TAKES: MOVIES AND POPULAR CULTURE

Quick Takes: Movies and Popular Culture is a series offering succinct overviews and high-quality writing on cutting-edge themes and issues in film studies. Authors offer both fresh perspectives on new areas of inquiry and original takes on established topics.

SERIES EDITORS:
Gwendolyn Audrey Foster is Willa Cather Professor of English and teaches film studies in the Department of English at the University of Nebraska, Lincoln.

Wheeler Winston Dixon is the James Ryan Endowed Professor of Film Studies and professor of English at the University of Nebraska, Lincoln.

Rebecca Bell-Metereau, *Transgender Cinema*
Blair Davis, *Comic Book Movies*
Steven Gerrard, *The Modern British Horror Film*
Barry Keith Grant, *Monster Cinema*
Daniel Herbert, *Film Remakes and Franchises*
Ian Olney, *Zombie Cinema*
Valérie K. Orlando, *New African Cinema*
Stephen Prince, *Digital Cinema*
Dahlia Schweitzer, *L.A. Private Eyes*
Steven Shaviro, *Digital Music Videos*
David Sterritt, *Rock 'n' Roll Movies*
John Wills, *Disney Culture*

• • • • • • • • • • • • • • • • • • • •

Digital
Cinema

• • • • • • • • • • • • • • • • • • • •

STEPHEN PRINCE

RUTGERS UNIVERSITY PRESS

New Brunswick, Camden, and Newark, New Jersey, and London

Library of Congress Cataloging-in-Publication Data
Names: Prince, Stephen, 1955– author.
Title: Digital cinema / by Stephen Prince.
Description: New Brunswick, New Jersey :
Rutgers University Press, 2019. |
Series: Quick takes: movies and popular culture |
Includes bibliographical references and index.
Identifiers: LCCN 2017060273| ISBN 9780813596273 (cloth :
alk. paper) | ISBN 9780813596266 (pbk. : alk. paper)
Subjects: LCSH: Digital cinematography. | Motion pictures—
History—21st century.
Classification: LCC TR860 .P78 2018 | DDC 777—dc23
LC record available at https://lccn.loc.gov/2017060273

A British Cataloging-in-Publication record for this book is
available from the British Library.

∞ The paper used in this publication meets the requirements of
the American National Standard for Information Sciences—
Permanence of Paper for Printed Library Materials,
ANSI Z39.48-1992.

www.rutgersuniversitypress.org

Manufactured in the United States of America

FOR SUSAN

CONTENTS

CONTENTS

DIGITAL CINEMA

INTRODUCTION

On May 9, 1893, Thomas Edison's kinetoscope had its public premiere. It was a peep-box device permitting a single viewer to look inside at a brief strip of film running over a light source. Intermittent motion and a shutter brought the sequential images to life. The image was not projected, and only one viewer at a time could sample the show. In this regard, the device did not have much longevity. The future of movies as a mass medium would be based on projected images viewed publicly by large audiences.

But we should not conclude that the kinetoscope and its single viewer are artifacts of cinema's prehistory. Time has doubled back on itself. In the digital era, solitary, small-screen viewing experiences are common. Mobile devices such as cell phones and tablets are today's counterparts of the kinetoscope, affording viewing pleasures and forms of spectatorship that need not be shared as part of a group. In the digital era, cinema has assumed myriad forms, and its viewers encounter it in numerous ways and contexts. It was not always so. For much of the history of cinema, it had a defined shape and location.

One left the home and entered a public space to see flickering images projected on a large screen. It was a collective and social experience.

And yet, though the interval between the kinetoscope and mobile video streaming is a long one, cinema itself has continually been reinvented. Filming and projection speeds were variable during the silent era until sound required that they be fixed and standardized. Black-and-white was the default medium for realism until color took its place in the middle 1960s. The shape of the projected image went from square to rectangular, and sound, when it finally arrived, went from a monochannel optical track to multichannel and digital formats. The machinery of cinema has been refined, upgraded, and altered, but for most of its history, it remained a photochemical medium in which a strip of film went from camera to lab to projector and thence to public viewing.

In the digital era, film has all but vanished, and in these pages, I wish to look at some of the contours and contexts of this vanishing and ask about its consequences. To what extent is cinema's reinvention in the digital era a game changer? Does it represent a decisive or definitive alteration to the medium as compared with earlier eras? Does electronic image creation and distribution represent a new order of change for the medium compared with the earlier revisions to its technology?

Exploring these questions, I take a prismatic approach. The angle of view, the conclusions reached, and the tone of discussion shift across the chapters, moving from conservative and reassuring to a more radical and bleaker outlook. Chapter 1 considers the relationship between cinema's analog and digital eras with regard to image creation and design. To what extent is the relationship between these eras one of continuity or rupture? In what ways does digital filmmaking build on and import image-making practices from the photochemical era and its storytelling conventions, and in what ways are we in wholly new territory? To answer these questions, I trace the factors and conditions that clarify the nature of cinema's analog-digital relationship when construed at the level of the image and its creation.

Chapter 2 examines cinema within a realist context and asks how concepts and methods of realist image making have persisted in the digital era. Realism is, arguably, a foundational concept in cinema that orients filmmaking practices and provides a framework within which viewers make assessments about movies and their images, stories, characters, and representations of familiar worlds. Within film theory, concepts of realism have been tied to photography, to photochemical imaging and the ways that a photochemical image is said to contain visible traces of those things that were before the camera. In a

digital world, pixels are protean and are not fixed in the way that a photochemical image is. Darkroom printing uses a "fixer" as the final stage in stabilizing the printed image and finishing it. No such comparable stage exists in digital imaging, which means that digital images can be endlessly altered. Does this mean that realism fails to operate or operates differently when images are electronically generated? Chapter 2, like its predecessor, finds that the continuities between the analog and digital eras are persuasive and strong.

Chapters 3–5 construct an alternative point of view about the relation between analog and digital. Chapter 3 examines how the digital era has enabled filmmakers to overcome the physical limitations that prevailed in earlier eras of filmmaking. These limitations were imposed by physical resources and by filmmaking equipment, and they restricted filmmakers in their ability to transcend physics in the depiction of characters and story situations. Filmmakers cheat physics today in numerous ways that can be more complex, ostentatious, or blatant than before. This practice, which is widespread, brings both advantages and disadvantages to contemporary filmmaking and has consequences for the ways that filmmakers, critics, and audiences feel about representative works. Cheating physics has become routine in the digital era, offering both blossom and blemish.

Chapter 4 looks at the emergence of a limit point for cinema, the appearance of a new medium that challenges cinema and its promise to deliver to viewers visual experiences that are supremely immersive and optically enveloping. For most of the history of cinema, it was the reigning champion at providing audiences with a projective illusion in which their experience of inhabiting a representational world was impressively persuasive and convincing. Virtual reality, however, has taken this experience to levels of perceptual immersion that go far beyond what cinema has provided. I examine the relationship of cinema and virtual reality with regard to medium characteristics and to their abilities to handle narrative, and I ask whether these might be one medium or are fundamentally different from each other. To the extent that the latter is true, cinema has a competitor that goes much further in providing projective illusion, a competitor and to some extent a replacement that the digital era has enabled.

Chapter 5 offers the most radical revision of the conclusions reached in chapters 1 and 2. It looks at the many ways that viewers encounter movies today and therefore at the means by which movies are distributed and circulate throughout culture. The shift away from a photochemical medium has entailed much-bigger changes than the loss of film. These include the loss of hard media formats in cinema, music, and literature. They have been

replaced by licensed electronic content available as digital streaming or downloads. On the one hand, streaming makes many things accessible for viewers, and it is cheap and convenient. But it also threatens to erase much of cinema's past and makes continued access to classic works more unpredictable and precarious than it was during the eras of hard media. Moreover, the physical resources required by the emergence of a global electronic culture may be environmentally unsustainable. In this regard, the digital matrix in which cinema now exists may prove threatening both to the medium's past and to its present continuity as a means for archiving human experience.

The perspectives that I am offering about digital cinema shift across the chapters in ways that I hope will suggest some of the topic's complexity. The kind of answers that one gives to questions about the relation between analog and digital cinema depends on the lens that one uses to frame the questions, the places that one looks, and the angle of view that one takes. This is prismatic and appropriately so because it is much like cinema itself. Cameras tell true lies about the world and about what they show. In my prismatic shifts of view across the chapters, I have tried to capture some of these truths and some of the myths.

1

CINEMA AS CONSTRUCTION
Then and Now

Steven Spielberg's *Jurassic Park* (1993) was not the first film with digital visual effects, but its box-office success made it the one that caused Hollywood to sit up and take notice. Those digital dinosaurs were revenue heaven. Over the film's lifetime, *Jurassic Park* earned more than $1 billion, and, of course, it spawned numerous profitable sequels. It seems reasonable, therefore, to ask a couple of questions in relation to the film and to what it may signify for cinema at large. If any single film can be taken as a benchmark, a historical marker gesturing toward that moment when cinema's analog identity and heritage gives way to a digital future, is it *Jurassic Park*? Or might it be *Star Wars: Episode II—Attack of the Clones* (2002), the first high-profile blockbuster to be shot digitally? In a larger context, what is the relation between cinema's analog past and its digital present? Is this relationship best

understood as one of continuity or rupture? Is there an analog/digital divide, much as there was with silent and sound cinema?

The idea of a "divide" tends to suggest that a break has occurred between modes, eras, or technologies. Sound filmmaking did replace silent cinema; digital image capture has largely replaced shooting on film. But in significant respects, the transition from film-based to digital formats has been slower and more gradual than was the industry's conversion to sound. Twenty years before *Jurassic Park*, computer graphics had appeared in Hollywood movies in the science fiction films *Westworld* (1973) and *Futureworld* (1976). Other films, as well, had included computer graphics: *Looker* (1981), *Star Trek II: The Wrath of Khan* (1982), *Tron* (1982), *The Last Starfighter* (1984), *Young Sherlock Holmes* (1985), *The Abyss* (1989), *Terminator 2* (1991). Prior to this, in the 1960s, basic research was under way to create pictures by digital means. Electronic computers have been around since the 1940s, and the U.S. Navy had a digital computer in 1951 that displayed real-time screen graphics. Numerous artists and engineers pursued the development of computer graphics in military, industrial, and academic research labs. They felt that computers could take pictures into new domains and offer powerful new tools and methods for manipulating and constructing images. Art and science commingled.

A digital artist working at Bell Labs published a paper in 1967 titled "The Digital Computer as a Creative Medium," in which he perceptively wrote that computer imaging would make a decisive and profound entry into art and culture. Michael Noll wrote that traditional artistic media would not be replaced or swept away, "but they will undoubtedly be influenced by this new active medium. The introduction of photography—the new medium of the last century—helped to drive painting away from representation, but it did not drive out painting. What the new creative computer medium will do to all of the art forms—painting, writing, dance, music, movies—should be exciting to observe" (90).

Jurassic Park, then, seems to mark that moment when digital imaging, built on decades of research into computer graphics, became salient in the imagination of popular audiences and that moment when the movie industry saw digital effects as a new engine for box-office growth. But the film does not mark a moment of historical transition, because the influx of digital tools into cinema was relatively slow and gradual. It is difficult to say exactly when a decisive shift occurred. It had been clear since the 1960s that computers were going to play a huge role in the future of picture making. Aware of the research under way on digital imaging, George Lucas funded a computer-graphics division at Lucasfilm in 1978 because he wanted

new filmmaking tools: a nonlinear editing system, a platform for digitally processing and mixing sound, and a digital printer for compositing shots that would replace the existing optical printers. These ambitions were consistent with the directions in which filmmaking overall was moving. Lucas had the first two tools a few years later. At the end of the 1980s and into the early '90s, Avid, Lightworks, and Adobe brought digital editing systems to market, and Hollywood embraced electronic cutting and splicing. In this same period, digital compositing displaced optical printing, and Disney was the first studio to move in this direction, with an all-digital composite on *The Rescuers Down Under* (1989). A decade later, digital cinematography began challenging traditional methods of shooting on film. John Bailey shot *The Anniversary Party* (2001) on digital video, and the following year, Lucas released *Star Wars: Episode II—Attack of the Clones*, which had been shot using specially commissioned Sony CineAlta cameras running at the film rate of twenty-four frames per second. In the same period, digital grading offered filmmakers new and more powerful electronic tools for adjusting light, color, and other image values in their footage. *Pleasantville* (1998) and *O Brother, Where Art Thou?* (2000) were the first films to carry digital grades. As with the optical printer and shooting on film, another venerable method of filmmaking was displaced. Digital grading

succeeded traditional methods of color timing achieved by photochemical printing in a lab. Digital production methods, then, were making numerous interventions into professional filmmaking, and digital visual effects were merely one outcome (albeit the most visible one for popular audiences) of the massive shifts of industry practice that were under way.

If these tectonic shifts occurred relatively slowly, does that mean there has been no rupture or divide in cinema history between the analog and digital eras? As I hope to show in these pages, this question can be answered affirmatively or negatively, depending on what factors one emphasizes. To write of cinema's analog identity or analog past is to make reference above all to the presence of film, a physically based medium rooted in photochemical processes from which positive prints or images were struck from a camera negative. The term *film* remains with us today, but if it is used in connection with contemporary cinema, it most often has a generic meaning, designating cinema generally or moving images generally. Although some movies continue to be shot on film, for all practical purposes, movies today are a thoroughly digital medium, from their inception to their creation and through the numerous ways that viewers today encounter them.

There are striking differences between photochemical images and electronic ones, between images that reside

on film and those that are composed of pixels. In some ways, film and digital video are opposites. Film handles highlights very well but does not see much information in shadows or dark areas. Digital video enables a filmmaker to extract a lot of information from shadow regions but presents numerous challenges in controlling highlights. Moreover, film has a granular structure. Photographic film has a plastic base attaching to a layer of emulsion gelatin containing light-sensitive silver halide crystals, and if it is color film, there are multiple layers of color dyes in the emulsion. The microscopic crystals are known as "grain," and their distribution varies frame by frame, as does the degree to which they are activated by light. As a result, when motion-picture film is projected, it has a special luminous quality that digital projection does not. It glows. By contrast, a digital image is composed of an array of pixels whose location is fixed. The release of Peter Jackson's *The Hobbit: An Unexpected Journey* (2012) made these differences disturbingly apparent. Shot digitally in a high frame rate of forty-eight frames per second, the hyperclarity of the projected images seemed radically unlike the look of film, to the chagrin of many critics and audiences. The *Toronto Star* wrote, "Watching 48fps is a bit disconcerting at first, a bit like gazing at a high-definition TV showing a live theatre presentation" (Fox). The *Village Voice* wrote, "This 'high-frame rate'

Hobbit features exceptionally sharp, plasticine images the likes of which we might never have seen on a movie screen before, but which *do* resemble what we see all the time on our HD television screens" (Fox). Hollywood's trade journal, *Variety*, wrote, "everything takes on an over-blown, artificial quality in which the phoniness of the sets and costumes becomes obvious" (Fox).

The ironic lesson here is that the softer look of film seemed preferable for these viewers to a pristine, hard-edged, hyperclear look resembling HD television. Digital suites today offer filmmakers numerous tools for placing filmic artifacts into digitally captured or created images, including grain, motion blur, lens flares, bokeh, and crushed blacks. Perhaps this is a form of technostalgia—a longing for a technology that has vanished—but it remains a striking development that film, while largely ceasing to exist as a physical medium, has maintained a kind of virtual presence amid the pixels and electronic circuitry that constitute contemporary cinema. Cinematographers have varying attitudes about the relative differences between film and digital video. Some prize the unique look of film, while others embrace the advantages that digital video affords them or feel that modern digital cameras capture images in a resolution matching that of film. *The Revenant* (2016), for example, about the nineteenth-century explorer Hugh Glass, who

was mauled by a bear and left for dead by his companions, was shot on location under harsh conditions in the Rocky Mountain region of Canada's Alberta province. Daylight was scarce, and the forested locations offered numerous dark, shadowed regions. The film was shot using natural light, and under these conditions, it would be harder for a film camera than for a digital camera to see the details in shadow regions. The cinematographer Emmanuel Lubezki shot digitally because he did not think film would work as well. "In the weather conditions and the short windows [of sunlight], the Alexa [camera] did great work. Even if the dynamic range is not exactly the same as film, what the Alexa was able to do in the low end was something we could never do with film. In these conditions, with lots of shadows and limited time with sunlight, it was a very good decision" (Goldman, "Left" 38, 40).

The visual effects artist John Knoll says, "I'm a fan of modern digital cameras; I like their stable colorimetry, their signal-to-noise characteristics and their tremendous light sensitivity. But you hear a lot of people saying there's a sort of harshness or coldness to digital, and that film has a warmth to it. . . . People like the stylization that film has" (Benjamin B, "Rebel" 50). In recognition of this preference, *Rogue One: A Star Wars Story* (2017) was shot digitally, and the images were then output with a film curve

that emulated the nonlinear color response of cinema's more traditional look.

Rodrigo Prieto, who shot Martin Scorsese's *Silence* (2017), about Jesuit priests in seventeenth-century Japan, valued the look of film for the production. "From the beginning, Marty and I agreed we'd shoot film and anamorphic. Film negative has a color depth that no digital camera has yet been able to reproduce, and *Silence* takes place in the natural world, so color nuance was important" (Bosley 41). The cinematographer Ed Lachman feels that the grain structure and color separation of film (due to the layers of dye in the emulsion) cannot be represented digitally. These things "create a sense of depth of color in the image that I find lacking in digital photography" (Stasukevich 56).

Is film, then, "better" than digital video? It depends on whom you ask. This is not a very useful question because each format follows a different path to creating images, and each has unique strengths and weaknesses. The formats are quite different, and today film has receded into a historical past. On the one hand, the analog and digital eras seem very distinct from each other—a photochemical medium has been replaced by an electronic medium, photographic images have been succeeded by pixels and binary numbers. Thus, we might conclude that the changeover from film to digital video

resembles the silent cinema / sound cinema divide, as a kind of rupture occurring within the flow of cinema history when an older format gets replaced by a newer one. And, indeed, early commentary about the analog to digital transition showed concern about what this change might mean for cinema. The title of a book published in 2001—*The End of Cinema as We Know It* (Lewis)—encapsulated the sense of crisis that the loss of a photochemical medium for a digital one seemed to portend. This sense of crisis had multiple causes. One involved fears about the potential loss of industry crafts and the artists who practiced them. If everything could be done in the computer, what would happen to the people and the skills involved in such areas as matte painting, miniature model design, or even production design with its reliance on physical sets? Digital tools threatened to remap existing craft areas. Cinematographers held great control and authority over how a film looked during the era of photochemical lab timing because only the cinematographer had the professional expertise of knowing how the timing lights worked and affected color balance. But the graphical user interface in a digital grading suite seemingly invited numerous participants to make changes in various picture elements. Digital grading threatened to alter the professional domain and responsibilities of the cinematographer.

Moreover, if the realities of real, physical props and locations were eroded by digital tools, then those tools might also weaken the connections between narrative and its investiture in real things and places. Spectacle—sheer visual excess—might take over from narrative and displace it. The onset of digital imaging revived a long-standing critical tradition that favored live-action drama over visual effects genres, such as fantasy and science fiction. Aylish Wood pointed to a "great divide of spectacle versus narrative" in film theory and criticism (370). Shilo T. McClean noted that the vast body of argument about visual effects and spectacle in the early digital era saw these as intrusions on narrative (34). Digital effects enabled filmmakers to extend and emphasize fantasy elements beyond what analog tools made possible. Michele Pierson suggested that the digital display of dinosaurs in *Jurassic Park* brought the narrative to a stop so that the visual effects could be savored by viewers (120). Spectacle is "the antithesis of narrative," wrote Andrew Darley. "Spectacle effectively halts motivated movement. . . . It exists for itself" (104). Scott Bukatman found that visual effects often evoke "a hallucinatory excess as narrative yields to kinetic spectatorial experience" (*Matters* 113). Annette Kuhn wrote that visual effects "tend to eclipse narrative, plot and character" (5). And Viva Paci found that "high tech" effects films capture audience attention

not through plot development but through gaudy, "shooting star effects" that address viewers at a sheer physical level (122). These concerns suggested that the digital intensification of visual effects might alter the terms of cinema's investment in narrative. But as scholars such as Geoff King, Dan North, and McClean and Wood have noted, narrative has persisted quite well in the digital realm, and visual effects artists themselves agree that a well-told story is the most important ingredient in any film.

Moreover, in regard to the physical props used in movies—matte paintings, models, sets—these have not been displaced by digital tools. Weta Workshop, for example, created numerous miniatures for use in Peter Jackson's *Lord of the Rings* films; the miniatures were then composited with matte paintings and live action. Physical sets create a sense of reality for the actors performing on them, and filmmakers in the digital era overwhelmingly value this attribute. David Fincher, who has used digital tools very innovatively in *Zodiac* (2007), *The Curious Case of Benjamin Button* (2008), and *The Social Network* (2010), maintains that "sets are very important, . . . almost more important for directors than actors" (63). J. J. Abrams, the director of *Star Trek: Into Darkness* (2013) and *Star Wars: The Force Awakens* (2015), emphasizes the importance of balancing digital elements with actual locations

or physical sets "to create a world that isn't synthetic or sterile, but feels very, very real" (*Set Decor Online*).

Star Wars: The Force Awakens had more than seventy physical sets, many of which were massive, such as the Niima Outpost, a marketplace for scavengers, which was constructed on location in Abu Dhabi. "It was like building a whole town out in the desert," said one of the production's designers (Witmer 74). Director Abrams wanted to anchor the digital elements in real, built environments: "making sure we were on actual sets and builds and locations whenever possible." He felt it made little sense to invest resources in postproduction, "trying to make something that nature is often giving you for free" (Fish 42). The digitally created locations in *Kong: Skull Island* (2017) were anchored with a full-scale village set, inhabited by the Skull Islanders, which was constructed in Vietnam (Edwards, "Lonely" 70).

Another, and major, set of factors that underlay the sense of crisis that the digital transition elicited involved attitudes about photographic images and the epistemology that attached to them. Photographic and digital images were taken as being inherently and fundamentally different from each other. Although many people use digital cameras today to take photographs, in that context, the term has a generic meaning. The specific meaning of *photograph* involves its connection with film, and it is in

regard to this connection that photographs and digital images are said to be inherently different. A photograph on film is said to be an indexical referent of that which is photographed. An index is causally connected to what it represents. As an index, a photograph testifies that what it pictures was present before the lens of the camera. The philosopher Charles S. Pierce devised a triadic model of communicational signs, and for him, the index communicated in terms of physical connection. "Photographs," he wrote, are in certain respects "exactly like the objects they represent. . . . They . . . correspond point by point to nature" (qtd. in Wollen 123–24). Roland Barthes emphasized that photographs can never be divorced from their referents, from what they picture. "I call 'photographic referent' not the *optionally* real thing to which an image or sign refers but the *necessarily* real thing which has been placed before the lens without which there would be no photograph" (5). For Barthes, photographs signify the presence of some object, scene, or event that was in front of the camera.

The eminent film historian and critic André Bazin based his conception of realism in cinema on the photographic properties of its images. He regarded photography as having an objective basis because it carries a mechanical trace of its referent. "The photographic image is the object itself, the object freed from the conditions of

time and space which govern it. No matter how fuzzy, distorted or discolored, no matter how lacking in documentary value the image may be, it shares, by virtue of the very process of its becoming, the being of the model of which it is the reproduction; it is the model" (14).

Long-established traditions of film theory and criticism have regarded cinema as being a photographic medium, and this, in turn, has entailed that live-action cinematography, in which actors, events, props, or sets are copresent before the camera, was seen as the medium's sine qua non. The indexical status of photography invested cinema with its essence, testifying to the organic reality and wholeness of events before the camera. As David Rodowick writes, "Comparing computer-generated images with film reaffirms that photography's principal powers are those of analogy and indexicality" (9). Digital images, it is said, lack indexical properties because they can so easily be faked and because that fakery could be so sophisticated as to be unrecognizable. They threatened to sever the connection between photography and truth, between reality and its photographic record. For Lev Manovich, digital images strip away cinema's analog heritage, the "deposits of reality" that photographs carry (342). The digital era has taken cinema away from its indexical origins, its ability to record reality. Because digital images enable elaborate fakery, according to Jonathan Crary, "visual images no

longer have any reference to the position of an observer in a 'real,' optically perceived world" (2). For Sean Cubitt, digital images "sever the link between meaning and truth, meaning and reference, meaning and observation" (250).

The epistemology surrounding photography, of course, minimizes the extent to which conventional photographs may be faked and minimizes as well the routine ways that photographers depart from nature by manipulating images through their choices about lenses, framing, and exposure or through darkroom techniques such as dodging and burning. More important, though, is the question of whether photography ought to be taken as the basis of cinema. Is cinema, in fact, a photographic medium? During the analog era, when the medium resided on film, this seemed to be an intuitive connection to make. Cinema seemed to be a photographic medium because it used cameras to record images on film and because audiences experienced movies as a film projection. Now that film has receded into the past, however, the connection is no longer as intuitive or compelling as it once seemed. Construing cinema as a photographic medium necessarily excluded important categories of production, such as animation and avant-garde films. Animation involved a succession of hand-drawn images or sequential puppet manipulation. Avant-garde films did not need to involve photography at all. Stan Brakhage used no camera in

making *Mothlight* (1963). Instead, he placed various natural objects—a blade of grass, moth wings—between two layers of splicing tape and then printed these assemblages directly onto film, which could then be projected for audiences.

The identification of cinema with photography also had the consequence of minimizing recognition of the extent to which cinema was a composited medium, a blending of numerous, diverse, and discrete elements. The final composite resided on a strip of film as a series of photographs, but the elements themselves consisted of hand-sketched line drawings, paintings, puppets, sculptures, architectural renderings of period décor, actors wearing costumes, and miniature models standing in for full-sized structures. The photographic biasing and the live-action biasing that have existed in generations of thought and theory about the movies have tended to deflect attention from the extent to which cinema is a composted collage of different ingredients. Noel Carroll points out that movies have been composed of many different kinds of nonphotographic things, which include numerals, words, blank leader, and abstract, nonrepresentational shapes, forms, and colors. For this reason—because cinema need not be representational—he argues that cinema is not a medium of moving pictures but of moving *images*. "Film is not one medium but many media." He adds,

"Photographic representation cannot be regarded as the basis of cinema" (*Engaging* 8).

Recognizing this fact enables us to understand that what might appear to be an analog/digital divide in cinema history at the level of the image is more like a process of continuity than a rupture. From the beginning of cinema, filmmakers have worked as collage artists by fashioning composites made up of diverse materials. They had to do this if they wanted to tell stories. Building fictional worlds required them to go beyond camera reality. Real locations or personnel often were not there—they might be inaccessible, unavailable, or nonexistent depending on the story setting or requirements. Cinema need not inhabit a narrative format, but its popular form has been overwhelmingly story driven. Camera reality could not serve this kind of mission, and so from its inception, filmmakers sought ways of countermanding and counterfeiting camera reality.

Throughout the silent era, filmmakers swiftly discovered ways to accomplish this. They created composite images by blending live action with matte paintings and miniature models and used matte and countermatte blends to conjoin live-action footage that had been photographed at different times. The Circus Maximus, where a chariot race occurs in *Ben Hur* (1925), was constructed as a two-story set, with a miniature model, hung a short

distance in front of the camera, furnishing the upper reaches of the coliseum. Hanging miniatures of this sort were widely used during the silent era as a way of achieving set extensions. Matte paintings provided another way of creating set extensions or of establishing landscapes beyond live-action areas on camera. Norman O. Dawn perfected the use of glass matte paintings to extend buildings or landscapes as early as 1907. The opening gag in Charlie Chaplin's *The Gold Rush* (1925) finds Charlie the tramp walking precariously along an icy path on the edge of an Alaskan mountain. The path and the rock face beside Chaplin were a set, and the epic expanse of mountains, sky, and valley were a glass matte painting composited in camera with the live action. Sheets of glass placed in front of the camera also facilitated blending miniature models with live action. The Schüfftan process, developed by Eugene Schüfftan for Fritz Lang's *Metropolis* (1927), used a glass mirror placed at a forty-five-degree angle to the camera. The mirror might reflect a miniature model or a matte painting, and if the reflective surface of the mirror were scraped off, the camera could film through that area to capture live action as an instant blend with the other composite elements. The Schüfftan process has been widely used, by Alfred Hitchcock in many of his films and by Peter Jackson in *The Lord of the Rings* movies.

Matte and countermatte blends of live action enabled filmmakers to create synthetic camera realities. The opening scene in *The Great Train Robbery* (1903) takes place in a telegraph operator's office. It has a window through which one can see a train passing by outside. The scene was constructed by filming the live-action footage, in which the robbers assault and tie up the telegraph operator, using a matte or mask to prevent exposure of that portion of the frame where the window would be. The film was rewound in the camera, and the train footage was added using a countermatte to block additional exposure of what had been previously filmed. The countermatte blocked all areas of the frame except for the window area. The result is a very convincing blend of material that had been filmed separately.

Harold Lloyd's *Safety Last* (1923) includes a famous sequence in which he scales a tall city building like a human fly. We see him dangling in what seems to be a very dangerous fashion from the edges of the building high above what are clearly real city streets. This exciting, funny sequence has an eye-popping, daredevil quality. Lloyd created it by cheating camera reality. A series of partial building exteriors were constructed as sets on the roofs of several real buildings of differing heights. In the story, the character climbs a single building. In reality, three buildings were used for scenes representing different stages of

the climb. The camera was in a tower atop these buildings next to the partial sets. What the camera seemed to see was all that mattered, and Lloyd calculated the angle of view that would make it seem as if he were hanging off the edge high above the street, instead of clinging to a partial set a few feet above a mattress safely laid on the roof of a building that was out of the camera's view.

When the optical printer was invented during the 1930s, laboratory compositing succeeded in-camera compositing. By interlinking a camera and projector, optical printers enabled filmmakers to create composite images by filming their elements separately and building the blend using mattes or masks to prevent double exposures. Many of the celebrated deep-focus shots in *Citizen Kane* were constructed in the optical printer. Studio-era filmmaking also widely used rear-screen projection to add landscapes behind actors performing on a set. Sets themselves were rarely built in their entirety—they were incomplete, partial representations of rooms or buildings, with composited elements added in the form of miniatures or matte paintings. Motion-control cinematography—the ability to make multiple camera movements that were exactly alike—developed in the 1940s at MGM as a means of using a camera move to blend live action with a matte painting. Two camera moves—one on the live-action set, the other on a matte painting in the laboratory—appear as

one in the composite. As seen in *Easter Parade* (1948) and *An American in Paris* (1952), the blends are completely convincing. Paramount Pictures also had a motion-repeater system for its cameras, which it first used in *Samson and Delilah* (1950) to fabricate a set for the Philistine temple, conjoining through camera movement a full-scale bottom third of the temple with a miniature model of the temple, built at one-third scale.

Editing provides filmmakers with another powerful means of cheating camera reality. What exists on screen and is established through editing does not correspond with what existed before the camera. In D. W. Griffith's *The Girl and Her Trust* (1912), Griffith used cuts on action to create adjacent spaces in the story's scenes that, in fact, were shot at different times on sets that did not adjoin one another. This kind of editing was a profound breakthrough in the art of cinematic storytelling. Silent-era Soviet filmmakers had a deeply informed under-standing of the power of editing to create new realities that transcended the photographic. Dziga Vertov's *Man with a Movie Camera* (1929) is a dizzying demonstration of the powers of montage to build up, break down, tear apart, and reassemble time and space as a distinctly cinematic idiom.

The constructed nature of cinema becomes especially apparent through editing when the nature of the blends

changes across a series of shots. In *King Kong* (1933), when Kong takes Ann Darrow (Fay Ray) back to his cave, Kong appears in the establishing shot as a full-body puppet (eighteen inches high), brought to life using stop-frame animation, in a miniature set composed of partial rock formations and a matte painting. "Ann" is a small doll in his hand. As he places her in a grotto, the film cuts to a medium shot blending the Kong puppet with a miniature rear-screen projection of Ann inside the grotto. Miniature rear projection enables the placement of a live actor into a miniature set. Then, as an animated puppet of a snake begins slithering up the rock wall toward Ann, the film cuts to live-action footage of the actress Fay Ray looking frightened, filmed in medium shot on a partial but full-scale set of the grotto. Then a cut back to the establishing shot shows the Kong and snake puppets, the full cave with the matte painting, and Ann in the grotto as a miniature rear-screen projection. The elements in the composites are different in each shot, changing with every cut.

In Alfred Hitchcock's *Notorious* (1946), Devlin (Cary Grant) and Alicia (Ingrid Bergman) travel to Rio de Janeiro. Second-unit footage of Rio provides establishing shots introducing the city. A cut takes us to an outdoor café where Devlin and Alicia converse, filmed in shot-reverse-shot close-ups. The café is a Hollywood set, with the streets and pedestrians added as a rear-screen

projection behind the actors, who are delivering their lines on an indoor studio set. They leave the café and take a car to an overlook high above the city. Grant and Bergman appear in long shot in a real location above a city and then walk into a partial studio set with the mountains and sea behind them as rear-screen elements. The editing transitions us through a succession of real and simulated locations. The indexical nature of photographic reality takes a back seat to the cinematic need to construct a narrative reality using all tools that are available.

Hollywood films in this era were shot on studio sound-stages and back lots, a practice that has come to be known as back-lot filming. In this respect, there are very clear continuities between the analog and digital eras of cinema. Two films whose narrative action ostensibly takes place in Casablanca, a port city in Morocco, provide a vivid illustration. Warner Bros.' *Casablanca* (1942) is a genuine Hollywood classic, a beloved film that went into production shortly after the bombing of Pearl Harbor. Like *Casablanca*, *Allied* (2016) is a World War II drama whose opening act takes place in the same Moroccan city. *Casablanca*, of course, was shot on film. *Allied* was filmed digitally using Red's Dragon camera at 6K resolution.

Casablanca was shot using sets and props that were recycled from other Warner Bros. productions and from the studio's in-house archive of materials (Lebo). In part,

this was due to wartime restrictions—a shortage of raw materials and military prohibitions against filming on Los Angeles locations outside the studio property—but the results were consistent with Hollywood back-lot filming practices. The Casablanca street set, where the city's market operates, also appears in Warner's *Desert Song* (1943), and the train station, where Rick (Humphrey Bogart) gets a farewell letter from Ilsa (Ingrid Bergman), the woman he loves, was being used concurrently by another Warner production, *Now, Voyager* (1942). It was dressed alternately as an American station and a French one.

Only two scenes involving airplanes were shot on location outside the studio. These were filmed at the Los Angeles Metropolitan Airport near Warner's studio lot in Burbank. Everything else was done in house, and the film's few scenes showing a wide view of the city were accomplished with glass shots using matte paintings to extend the sets. The establishing shot of the Casablanca marketplace, for example, composites a glass matte painting of a mosque, a minaret, and the surrounding city positioned above the marketplace set. The matte painting provides one of the film's few expansive views of the city and also serves the practical function of blocking views of the Burbank skyline above the set. The city of Casablanca in this enduring film classic has a virtual existence, appearing only as a series of Burbank sets and matte paintings.

Existing studio practices coupled with the unique war-time restrictions dictated this design. There would be no real locations, and sets and props would be recycled from other productions. The material presence of the world in the story would be completely fabricated.

Allied, a World War II espionage thriller starring Brad Pitt and Marion Cotillard, was filmed almost entirely on indoor studio sets and blue-screen stages whose relatively small dimensions were extended using digital tools and often were enlarged into expansive exterior settings. In this case, however, the decision to work indoors was a matter of choice rather than necessity. The film's director, Robert Zemeckis, much preferred the control provided by working in a built environment using sets and blue screens. About his preference, Zemeckis remarked, "Any time you [shoot] outside, you have no control. . . . No matter what you do outside, in my opinion you have to compromise three to four times more than when you are in a controlled environment" (Goldman, "Love" 50).

Digital tools enabled the filmmakers to simulate on London soundstages the necessary story settings. The film's lengthy opening shot, for example, finds the British agent Max Vatan (Pitt) parachuting into the Sahara desert, en route to Casablanca. In the finished film, the viewer sees him pirouetting around as he descends. The camera pulls back to a long, wide framing, leaving Max

in the distance, and then it moves back in to an extreme close-up of his face once he has landed. All of this action was a simulation. Pitt was filmed against blue screen in a wired harness that lowered him fifteen feet to a small area of real sand on the blue-screen stage. A key light orbited around him to simulate the character's movement in relation to the sun as he circled and fell through space. For fine-tuning of the scene's choreography, Pitt's live-action performance was projected onto a match-moved digital double. When the camera pulled back to long shot, a computer-generated (CG) character replaced the actor. Throughout, Pitt was composited with high-resolution footage of a sea of Saharan dunes. A 3-D digital environment was built from this aerial footage, which was then projected as textures onto the digi-environment. Digital artists simulated windblown sand moving across the dunes to create a fully sculpted environmental geometry. The complexity of the simulation ruled out the use of matte paintings, so the environment had to be fully built as a 3-D construction.

When Max arrives at Casablanca, the city's exterior was depicted as a five-mile-wide urban environment consisting of numerous buildings, all based on photographic surveys of Tangiers architecture. These panoramic views of the city show its size and scale, unlike *Casablanca*, which lacked expansive views of the city. Again everything

was built in 3-D without matte paintings because many shots included complex changes in perspective. Scenes where Max and Marianne drive through the city were accomplished using digital extensions of old-school rear projection. Car interiors with the actors were filmed on soundstages in London, and the automobile rigs were surrounded with one hundred feet of LED screens that displayed footage of the digital city. Light from the screens created interactive reflections and shadows on the actors inside the car rigs (which old-school rear projection never did) and gave them something to act with and in relation to.

Using LED screens to create interactive lighting is a common feature of contemporary digital filmmaking. The sets for *Deepwater Horizon* (2016), which portrays the explosion of the Deepwater oil rig in the Gulf of Mexico, were backed with LEDs that displayed footage of fire and the burning rig, throwing dynamic lighting effects onto the set and the actors. All of the cockpit scenes in *Rogue One: A Star Wars Story* were done with LEDs instead of blue-screen environments. These provided an efficient way of creating the complex lighting effects that would be elicited by traveling through environs with numerous sources of illumination, such as a city. The film's visual effects supervisor, John Knoll, points out that "the lighting environment around the vehicle should really be

changing almost every frame" (Benjamin B, "Rebel" 48).
Creating that environment and having it play back on the
screens enables filmmakers to capture the subtleties of
traveling with attendant changes in light and color, and,
according to Knoll, "it looks a lot better."

Although the story locations that *Casablanca* estab-
lished with sets, miniatures, and paintings were partial—
only what the camera saw was built—the settings in *Allied*
were more radically incomplete. Wide, panoramic views
were almost always digital composites, and even with
an intimate scene, the live-action set might be minimal.
Max and Marianne consummate their affair on the front
seat of a Citroen automobile, parked in the desert, as a
sandstorm begins to boil around the car. The minimal set
consisted only of the car's bench seat and steering wheel,
yet on screen, their scene of lovemaking unfolds with
a camera inside a fully visualized automobile, circling
around its interior and the characters as the sandstorm
rages outside, visible through the windows. Circular
dolly tracks enclosed the set and actors, and two cameras
moved along the tracks to film the scene. The missing
areas of the car were composited as digital creations, and
the car's geometry was subtly warped to increase the audi-
ence's sense that the camera was inside the cramped inte-
rior with the actors. The car's digitally simulated interior
was animated to respond to the movements of the actors,

so that when they bumped into a portion of the car, it moved slightly to register the impact. Digital doubles of the actors were used to cast shadows and reflections on portions of the auto interior. A bank of LED screens displayed high-resolution footage of the desert, derived from photogrammetry (a method of using photographs to measure and mark a three-dimensional environment), which transformed via fluid simulations into a sandstorm. The sandstorm animation was designed to mimic the interactive lighting effects from the LED panels to the actors' faces.

This intimate, emotional, sensual scene offered viewers a convincing blend of live-action performance and a virtual setting. About the finished scene, the film's visual effects supervisor, Kevin Baillie, remarked, "There is so much happening between these real actors and this digital environment that is super subtle. But hopefully people will watch it and just say, 'That was a hot scene inside the car.' Only movie people will think: 'How the hell did they get the camera inside the car. That's impossible!'" (Edwards, "Love" 109).

Although the tools used by the filmmakers had changed, the production tradition exemplified by *Casablanca* and *Allied* has not. Cinema is an art of the fragment. Partial views, partial realities that are built up shot by shot, become a gestalt in the minds of viewers, synthesized into

meaningful wholes that in most cases never existed in the ways that they appear on screen. Narrative filmmaking is an elegant construction, and although cameras continue to capture screen images for audiences, cinema now as in the past is not fundamentally a photographic medium, if that is construed as involving a necessary continuity between camera reality and screen reality. In this respect, the digital era has grown out of, and remains connected with, the analog era. The same fundamental conditions of cinema pertain to both. As the cinematographer Caleb Deschanel has remarked, "What we do in the movies—all the work that goes into costumes and props, set design and performances—it's all ephemeral" (Holben 80). Once a scene is over, you throw away all the elements. "The set is revamped, the costumes go back into a closet somewhere, the actors go on to become other characters in other movies—and all those creations that went into making you believe you're in the story just evaporate." What counts, Deschanel says, is that moment when all the pieces are brought together. "When it's recorded on film or on digital, that is where it gets its value. On its own, it doesn't mean anything" (Holben 80).

The visual effects supervisor on *Star Wars: The Force Awakens* has remarked, "The reality is that digital extensions are part of the modern filmmaker's toolbox" (Kadner, "Blurring" 83). But let us take a broader view. Set

extensions have always been part of that toolbox. In earlier decades, they were accomplished with miniatures and matte paintings. Wholeness, connection, completeness, continuity—these are qualities that filmmakers learned to suggest and to create. They discovered ways of placing the camera, of editing images, and of compositing shots so that the true conditions of cinema—the fragmentary, evanescent, and ephemeral nature of its elements—would engender a gestalt of wholeness and interconnection in the minds of viewers and would, in turn, underlie the pleasure that viewers might find in the medium. Shooting on film or shooting digitally did not change this practice. But that is not the whole story about the analog-digital relationship, as we shall see.

2

REASONS FOR REALISM

During the analog era, as we have seen, cinema seemed to be a natural extension of photography. As a series of moving photographic images, cinema testified to the reality of what had been before the camera. Of course, this conceptual model minimized or downplayed the numerous ways in which photographic images might furnish unreliable testimony about events or their meaning. It also minimized the composited nature of cinema and the fragmentary elements from which it is constructed. It privileged live-action cinematography. Because of the conceptual and cultural investiture in photochemical images, the onset of digital imaging struck many observers as a potential threat to the realism and integrity of photography and by extension of cinema itself. We sampled some of that commentary in chapter 1.

Has digital image capture undermined or weakened cinema's ability to function in relation to photographic realism? Because digital images can be endlessly

manipulated and altered, does that undermine photography's traditional role in documenting actual events? Does *realism* remain a useful term for considering some of the ways in which cinema (and photography) might operate in the digital era? The title of this chapter is borrowed from an essay by the perceptual psychologist J. J. Gibson (1982), and with it, I would like to suggest that there are numerous reasons for acknowledging that realism continues to operate as an important conceptual and stylistic category in contemporary cinema. These reasons are tied to existential factors, to photography's ability to furnish a record of being in the world, and also to stylistic factors, to the ways in which digital filmmakers might use their tools. In regard to both sets of factors—the existential and the stylistic—digital imaging has enhanced and increased the available reasons for realism. But I would also like to add an important caveat and its ominous implications with respect to digital realism.

Before the digital era, the archival nature of photography played a more limited role in covering historical events. When President John F. Kennedy was assassinated on November 3, 1963, he was riding in a limousine in Dallas before a large crowd of onlookers who had assembled to greet and view the president. Despite the public nature of this tragic event and the fact that it unfolded before numerous eyewitnesses and photographers, only one

film of the shooting that captures a clear view of the kill-
ing head shot is known to exist. Abraham Zapruder was a
clothing manufacturer whose office was located in Dea-
ley Plaza, where the ambush on the president occurred,
and he had decided to film the Kennedy entourage as it
passed through the plaza. Zapruder used an 8mm Bell
and Howell camera, and the twenty-seven seconds (486
frames) of Kodak Kodachrome footage that he shot fur-
nishes the chief visual record in motion of these nation-
altering events.

Before the digital era, many people had 8mm movie
cameras that they used to record memorable, if mundane,
family events. Compared with today's technology, the
process was cumbersome. You had to buy film ahead of
time, load the camera, expose the footage, then remove it
and take it to a lab for processing. To see the movie, you
had to load the exposed film into an 8mm projector. As
a result of this relatively laborious set of tasks, the wide-
spread, spontaneous filming of startling, breaking events
that we take for granted today was not a ubiquitous fea-
ture of culture and society. One of the tremendous effects
of today's digital imaging is the proliferation of continu-
ous surveillance. Little happens in the world today that is
not or has not been filmed. Much of this occurs below the
radar, below public awareness, in the form of surveillance
by security authorities, conducted at strategic venues

such as traffic lights, airports, stores, and stadiums. In urban areas, cameras concealed from view scan pedestrians for potential threats using facial-recognition software. Public surveillance by security forces is constant and ongoing. But surveillance also pushes in the other direction. Cameras proliferate in consumer electronic devices, such as cell phones, tablets, webcams, and motor vehicles. Ordinary people use these to watch, witness, and document events occurring in public spaces. These cameras have vastly enlarged the archival role that photographic images are playing in contemporary culture, capturing and documenting events, especially those possessing special salience or social significance. The ubiquity of digital devices and the ease with which they can be used, the speed at which they enable one to capture moving images, is unprecedented in comparison with the analog era.

The destruction of the World Trade Center on 9/11, for example, is one of the most photographed events in human history. Between the time that hijackers flew American Airlines Flight 11 into the North Tower and its subsequent collapse, 102 minutes elapsed. The South Tower fell first, hit by United Airlines Flight 175 seven minutes after the North Tower was struck. The length of time the towers continued to stand following impact enabled thousands of witnesses to take pictures of what

was happening, and these photographs and videos, shot largely by amateurs using digital cameras, provide a profoundly powerful record of these events. Numerous documentary films are based on this archival record, including *In Memoriam: New York City* (2002), *7 Days in September* (2004), and *102 Minutes That Changed America* (2008). Even the conspiracy films—*Loose Change* (2004), *911: In Plane Sight* (2004), *911 Mysteries Part 1: Demolitions* (2006)—which allege that these events were orchestrated by the U.S. government in an attack on its own citizens, proceed by closely analyzing the visual record provided by this amateur footage.

The prevalence of digital cameras among amateur onlookers and professional photographers facilitated the compilation of an enormous body of material that has been used to convey the traditional mission and message of documentary filmmaking—its forcible assertion that *this happened* and these things looked and sounded like this. *9/11* (2002) was filmed on digital-video cameras by two French filmmakers and brothers, Jules and Gédéon Naudet, who were in New York making a documentary about how a rookie firefighter learns the job. They were working and living among the firefighters of Engine 7, Ladder 1, at a station very near the World Trade Center, and events overtook their planned film, transforming it into something far more dramatic and unanticipated. On

the morning of September 11, Jules accompanied a group of firefighters from the station on a trip to investigate a complaint of a gas leak. Their location was in view of the World Trade Center. The sound of a low-flying plane over the city—a rare, anomalous event—made Jules look up as he continued to film, and he inadvertently captured the only footage providing a clear sightline on American Flight 11 flying into the North Tower. The plane slams into the tower in silence, and then after several moments, the sound wave of the explosion reaches the camera and is recorded, along with the astonished reactions of other firefighters. One, off-camera, exclaims, "Oh, shit! Oh, shit!" again and again. As firefighters, they know well what this portends and that it probably is not an accident.

Jules accompanies Fire Department of New York (FDNY) chief Joseph Pfeifer and a company from Engine 7, Ladder 1, into the lobby of the North Tower, where Pfeifer sets up a command post. Amid the exploded, shattered windows of the lobby—blown out by gas fuel exploding out of the elevator shafts—Jules Naudet films the organized chaos of the firefighters' efforts to respond to an unprecedented disaster. He captures their grim faces, including the FDNY chaplain Mychal Judge praying silently and contemplating the terrible things he knows are coming. Judge was later killed by falling

debris. Throughout Naudet's footage, awful crashes make a booming sound—these are bodies of people who jumped from top floors striking the awning that covered the VIP driveway on the west side of the building. The booming crashes make firefighters in the lobby flinch and duck. Naudet also captures an exchange of glances between Chief Pfeifer and his brother, Kevin, a lieutenant who was about to make an ascent with his men for the upper floors of the North Tower. Kevin was killed in the tower's collapse.

Gédéon Naudet, who had been at the station, began walking to the trade center in an effort to find his brother. As he went, he filmed people watching, stunned, as the tower burned. As he panned and tilted the camera between the people watching and the towers, United Airlines Flight 175 abruptly appears in the sky headed for the South Tower. Naudet's spontaneous reactions with the camera furnish a vivid testimony about the shocking nature of what is seen. As the plane flies suddenly into frame moments from striking the building, Naudet sees it through the camera and flinches away, wrenching the camera toward the ground, losing sight of the building, wobbling the camera erratically. He then resights the towers with the south one now engulfed in flames. Naudet's unscripted responses are emblematic ones. The candid footage of 9/11 often carries traces of the camera

operators' emotional responses to what they are filming. Frequently these are verbalized, captured in the digital cameras' sound cards.

In *7 Days in September*, an amateur videographer impulsively films a body falling from the tower and zooms in for a closer view, then thinks better of it and turns off the camera. "I didn't want to have anybody else's death on my hands," he says later. As a videographer films a jumper in *In Memoriam: New York City*, another onlooker in the background can be heard saying, "Come on, don't take pictures of that. What's the matter with you?" In *102 Minutes That Changed America*, a young woman filming the burning Trade Center is heard suddenly exclaiming, "That—what is that falling? Oh my God, don't be a person." The digital footage captured in camera provides a record not just of the physical events transpiring that day but also of the spontaneous responses by camera operators, responses that range from an empathetic bonding with the victims whose deaths they witness to moral reflections on the propriety of filming such things, on the ethics that inhere in the act of photography and the photographer's moral relationship with the images that are created. In *9/11*, upon entering the North Tower lobby, Jules Naudet saw several people who had been burned to death, and he chose not to film them, reasoning that no one should see such things.

The audio record captured in camera provides other tangible details about what was occurring. The roar of the planes, the booming explosions, and the shrieks of onlookers registering the horror of what they see all furnish essential portraits of what happened, its sensory details and its emotional meanings. The availability of this digital audio record differs from the 8mm and 16mm film records of earlier eras. The Zapruder film is silent, as are many of the 16mm films made by John Ford's Field Photographic Unit in World War II, as are the films George Stevens shot of the liberation of captives at the Dachau concentration camp.

The prevalence of portable digital cameras opened a pathway to covering the Iraq War for documentary filmmakers that went beyond what was possible in previous wars. Filmmakers provided first-person accounts of their travels in the war zones and what they saw, and soldiers in the war had cameras they routinely used to document their experiences. As Javal Davis, a military policeman (MP) at Abu Ghraib prison, remarked, "Everyone in theater had a digital camera. Everyone was taking pictures of everything, from detainees to death" (Gourevitch and Morris 179). *Occupation: Dreamland* (2005), *Gunnar Palace* (2005), *Combat Diary: The Marines of Lima Company* (2006), and *The War Tapes* (2006) draw on candid footage shot by American soldiers in Iraq to construct

accounts of their experiences, while such films as *Inside Iraq: The Untold Stories* (2004) and *Battleground: 21 Days at the Edge of Empire* (2005) search out Iraqi points of view on the conflict.

The pictures of prisoner abuse at Abu Ghraib caused worldwide revulsion and became iconic, enduring images of the American presence in Iraq. Military police personnel, ordered to soften up prisoners for harsh interrogation by CIA officials and other shadowy agencies, posed the Iraqi prisoners in simulated sex acts, chained them to pipes and bed frames for long hours, left them standing naked in puddles of their urine, and humiliated them by placing women's panties on their heads and faces. The MPs took thousands of pictures, which were leaked to the media. Many were taken by two MPs—Charles Graner and Sabrina Harman—using a Sony FD Mavica and a Sony Cybershot camera. The metadata embedded in the digital photos—information about date and time, focal length and exposure—enabled army investigators to assemble a timeline of when the episodes of abuse occurred and their duration. Conventional photographs on film lack this kind of metadata.

One of the most famous of these images shows Harman posing next to the dead body of a prisoner who had been killed during interrogation. Manadel al-Jamadi was a ghost prisoner, a captive whose presence was meant to

be kept secret, so no record of his captivity or interrogation was kept. In the picture, Harman squats beside the body, grins at the camera, and flashes a thumbs-up sign, which makes it appear that she is complicit in the death and that the body is her trophy. These were among the meanings widely assigned to the image, but Harman and Graner, who took the photo, accidently found the body in a closet, where it had been concealed. Neither had been part of the interrogation that killed the victim, and Harman subsequently went back and took more pictures of al-Jamadi to create a visual record of his battered face and body in order to disprove the official explanation that he had died of a heart attack. Interviewed in Errol Morris's documentary *Standard Operating Procedure* (2008), she expressed the enduring historical faith in the evidentiary power of photography, its ability to furnish *evidence*. She said, "If I come up to you and say, 'Hey, this is going on,' you probably wouldn't believe me unless I had something to show you. So if I say, 'Hey, this is going on. Look, I have proof,' you can't deny it."

As the photo of Harman with al-Jamadi indicates, problems of meaning are inseparable from the camera's ability to photographically record events. Meanings exist within but also beyond the photographic record, and sometimes those meanings, when contextualized, are other than what an image seems to suggest. This has been true in the

analog as well as the digital era. As noted, the photo of Harman makes her appear to be one of al-Jamadi's murderers. Another iconic Abu Ghraib image is the hooded man, standing on a box, draped in a blanket like a poncho, head and face concealed under the hood, with wires attached to his hands and fingers. He had been told that he would be electrocuted if he stepped off the box, but the wires were not hooked to anything electrical. The disturbing nature of the picture is due in part to its weird and mysterious appearance. As Philip Gourevitch wrote, "It creates an original image of inhumanity that admits no immediately self-evident reading. Its fascination resides, in large part, in its mystery and inscrutability—in all that is concealed by all that is revealed. It is an image of carnival weirdness" (Gourevitch and Morris 183).

Digital image capture, then, played an essential role in the archival record of the September 11 attacks and the Iraq War that followed, and this material, in turn, helped to make possible the large number of documentary films that followed in the wake of these events. The fact that so many people now have digital cameras in portable electronic devices has altered our awareness of the world by bringing numerous events, traditionally hidden from view, into public scrutiny. African Americans have complained for decades that encounters with the police are dangerous, but such complaints had little

social impact until recently. Footage from witnesses' cameras and police dashcams and bodycams has depicted numerous traffic stops or other encounters between police and black Americans that turned deadly, ending with a black victim, often unarmed, killed by police. On July 17, 2014, for example, a bystander with a cell phone filmed Eric Garner being questioned by police on Staten Island about selling unlicensed cigarettes and then being restrained by an officer in an illegal choke hold and taken to the ground. Garner can be heard complaining repeatedly that he cannot breathe, and he lost consciousness. He was taken by ambulance to a hospital, where he was pronounced dead. On April 4, 2015, a bystander with a cell phone captured the North Charleston, South Carolina, officer Michael Slager shooting Walter Scott, who was unarmed, numerous times from behind as Scott tried to run away from him. Slager had pulled Scott over because the brake light on his car was broken. On July 6, 2016, police dashcam footage showed a Minnesota officer firing four times into Philandro Castile's car. Castile was unarmed, though he had just told the officer that he had a gun in the car and was licensed to carry it and had agreed not to take it out. Immediately after the shooting, Castile's girlfriend, Diamond Reynolds, used her cell phone to livestream via Facebook video of Philandro's death and her interactions with the police. The video begins seconds

after the shooting and captures Philandro moaning and writhing and Reynolds being ordered to her knees and being handcuffed as she narrates in camera the events that are occurring.

These videos and others like them illustrate what many black Americans have been saying for years about police encounters, although the tendency for juries to excuse the actions of police officers points again to the contested nature of photographic meaning, as something that is constructed outside and beyond the images themselves. Although this does not discount the evidentiary nature of photographs as records of events, it is a reminder that the realism attributed to still and moving photographs is complex, multifaceted, and constructed rather than reliably straightforward. Within a documentary context, digital imaging has not changed the manner in which photographic evidence is inextricably enmeshed within the turmoil of the social world. But digital imaging has greatly enlarged the scope of the camera and the domain of filmmaking and filmmakers as participant media trans- acting spontaneously with the flow of events. Diamond Reynolds instinctively, shrewdly became a filmmaker, turning immediately to digital media to capture, frame, and editorialize about the tragedy and horror in which she and her daughter were enmeshed, and then used the internet as a distribution platform so that what happened

aluated by viewers according to standards
s difficult to see how storytelling prac-
urage audiences to identify characters as
be changed or undermined by a shift to
es.

k, I have described another type of real-
lled perceptual realism (*Digital*; "True").
the array of real-world visual and audi-
sual effects artists build into shots and
vhile being fantastical or spectacular on
nevertheless aim to persuade viewers
e seeing is real within the story world
credible and convincing. Digital meth-
provide visual effects artists with more
e articulate imaging tools, and for this
iscussed elsewhere, the degrees of per-
tainable in digital cinema are greater
g cinema.

tists have spent decades closely study-
light across a variety of environments,
s, fire, water and rain, the texture and
hair, the subtle coloring and trans-
fascia, and numerous other physical
pirical world. They have learned how
ements in a digital world, and multi-
ecuted in stages, enables the control

would become public in a visible way, ensuring that it
would not remain a story whose preferred version would
be narrated by the police.

Before shifting the focus of our discussion, let us pause
to consider some darker implications of digital technol-
ogies in relation to questions of realism. Digital imagery
and audio now can be used to create fake footage of peo-
ple doing or saying things that they never did do or say.
After the shootings that killed seventeen students and
staff at Marjory Stoneman Douglas High School in Park-
land, Florida, for example, surviving classmates spoke
out publicly in favor of gun-control legislation. Their
activism received a great deal of media coverage. Almost
immediately, a concerted internet campaign mobilized to
undercut and discredit their message. Video clips posing
as news footage fabricated their images and voices. These
were distributed via websites and social media, and they
showed the students doing and saying inflammatory
things, which had no basis in reality.

Robert Chesney and Danielle Citron call this phenom-
enon "deep fakes." The term "refers to digital manipula-
tion of sound, images, or video to impersonate someone
or make it appear that a person did something—and to
do so in a manner that is increasingly realistic, to the point
that the unaided observer cannot detect the fake." The
authors cite numerous potential applications: fake videos

could show public officials taking bribes or uttering racial slurs, soldiers could be depicted slaughtering civilians in a war zone, politicians on the eve of an election could be shown engaged in criminal behavior.

The conclusions that Chesney and Citron draw from this are ominous:

> The spread of deep fakes will threaten to erode the trust necessary for democracy to function effectively, for two reasons. First, and most obviously, the marketplace of ideas will be injected with a particularly-dangerous form of falsehood. Second, and more subtly, the public may become more willing to disbelieve true but uncomfortable facts. Cognitive biases already encourage resistance to such facts, but awareness of ubiquitous deep fakes may enhance that tendency, providing a ready excuse to disregard unwelcome evidence. At a minimum, as fake videos become widespread, the public may have difficulty believing what their eyes (or ears) are telling them—even when the information is quite real.

The proliferation of deep fakes threatens to accentuate the political and social polarization that already characterizes U.S. society and promises to fulfill the fearful prophecies of early commentators on the shift from analog to digital imaging who saw the change as one that might undermine reality itself.

Let us now
text to that of fi
of our familiar
there in digita
pery concept
can mean ma
which it is cu
tives in ciner
The first
quickly. Na
courages vi
characters
edge abou
do. Audie
rative in
correspo
behavior
(and oft
ular ger
knowle
ogy an
charac
ars. C
the fis
tives.
dime

are routinely e
of realism. It
tices that enco
persons would
digital modaliti
In earlier wo
ism that I have c
This pertains to
tory cues that v
sequences that,
a narrative level
that what they a
and is therefore
ods of production
powerful and mo
reason, as I have
ceptual realism o
than those in anal
Digital effects a
ing the behavior o
in solids and liqui
behavior of fur an
lucence of skin and
properties of the er
to render these as e
pass compositing, e

of fine-grained details. As Roger Guyet, the visual effects supervisor on *Star Wars: The Force Awakens*, points out, "We do a lot of painstaking research on the environments we're trying to put our elements into. If we're recreating a desert, for example, we do a lot of research into how those kinds of environments and materials behave" (Kadner, "Blurring" 79–80). In Disney's live-action remake of *The Jungle Book* (2016), the main character, Mowgli, was played by a flesh-and-blood actor who was composited with all-digital environments and animal characters. Trees, vines, and other plant life in the jungle had to look photorealistic (Schwank, James, and Micilotta). In *Zootopia* (2016), the characters are anthropomorphic mammals that had to move like animals yet possess human-like personalities. The effects artists sought to blend these elements, and they used flesh simulation to add vitality to the characters. "Flesh simulation adds details such as self-collision, volume preservation, and jiggle that makes the characters feel more alive" (Milne et al.).

Perceptual realism is a powerful constituent of contemporary digital films, helping to establish credible environments and characters when these are created digitally rather than through live-action cinematography. Even though characters might be referentially false, nonexistent or never existing, they can be made to appear perceptually real.

Realism in cinema has two additional and important contexts in which it operates. These involve spatiotemporal considerations and issues of resolution and luminance affecting the amount of information that the image contains. Spatiotemporal considerations bear directly on André Bazin's well-known proposition that deep focus and the long take were inherently more realistic as cinematic techniques than montage was. "Realism," he wrote, "resides in the homogeneity of space" (50n). Deep focus and the long take, he wrote, "confirm our sense of natural reality" (110). Long takes in place of classical cutting enable a filmmaker "to analyze the dramatic field in time" (34). Furthermore, "depth of focus brings the spectator into a relation with the image closer to that which he enjoys with reality" (35). Doing so, it implies a more active mental attitude on the part of the viewer; the meaning of the image results in part from the viewer's attention, a process that honors a role for subjectivity in the construction of a perceivable reality, which Bazin believed was ethically and epistemologically important. In other words, depth of focus introduces "ambiguity into the structure of the image" (36), which montage worked to curtail. Bazin believed that extensive depth of focus was a key advance in the history of cinema. He wrote, "Depth of field is not just a stock in trade of the cameraman like the use of a series of filters

or ... a style of lighting, it is a capital gain in the field of direction—a dialectical step forward in the history of film language" (35).

Depth of focus in film differs from our normative way of seeing the world in that it evokes no vergence movements of the eyes—which we make by converging or diverging our eyes to fixate on objects at differing distances in the three-dimensional world. This is because the film image remains a planar, 2-D projection. Everything in it lies at a single distance from the viewer. It seems likely, however that deep-focus cinematography functioned partly as a mode for simulating the experience of viewing stereoscopic images. Stereoscopic displays predated photography, and attempts to adapt cinema to stereoscopic formats followed immediately upon the invention of movies and have persisted throughout the medium's history. Deep focus provides an approximation, within the planar, 2-D format that has characterized cinema, of stereoscopic vision. Moreover, stereoscopic displays have a natural affinity for deep focus. Although Bazin did not link the realism of deep focus to stereoscopy, it seems likely that this connection underlay his idea that deep focus results in heightening the viewer's sense of reality.

For filmmakers working in traditional, analog cinema, deep focus represents a stylistic choice and one that departs from the normative tradition that emphasizes

narrowed and selective focus, whereby parts of the image are allowed to remain a blur. Selective focus serves storytelling in a strategic way—the focal plane of the image (what is in focus and what is out of focus) tells the viewer about narratively important objects and events.

The norms of storytelling have not changed much in digital cinema; classical cutting remains the dominant paradigm, as does selective focus. But the early-generation digital cameras carried an inherent biasing toward deep focus that analog, film-based cameras did not. This is because digital cameras—used in still photography as well as in video—used image sensors that were smaller than a frame of 35mm film. Prominent early-generation digital video cameras such as the Thomson Viper (used to film Michael Mann's *Collateral* [2004] and David Fincher's *Zodiac* [2007]) or Sony's CineAlta used sensors that produced two and a half times the depth of field at the same angle of view as 35mm film.

This difference made deep focus a default norm when shooting digital video, and controlling depth of field to achieve selective focus was an ongoing challenge for the cinematographer Harris Savides on *Zodiac*. On bright sets or exteriors, he used neutral-density (ND) filters to lower exposure and reduce depth of field, and he also created selective-focus shots by placing actors in the rear of the focal plane so that the backgrounds would read as soft.

Filmmakers using digital cameras greatly desired the ability to shoot shallow-focus compositions, as their counterparts had been doing in analog formats for generations. The camera manufacturers complied. Beginning with the Red One camera in 2007, subsequent generations of HD or super-HD cameras have used a Super 35–sized sensor, which provides the same angle of view as a film camera and the same opportunities for using shallow focus.

But even though the imaging characteristics of today's digital cameras emulate many features of 35mm film cameras, their image sensors remain very sensitive, and controlling highlights—keeping them from burning out—is an issue. Cinematographers shooting on film often overexpose slightly to produce a thicker negative that can be printed down for rich blacks and to produce more information in the highlights. Overexposing entails opening up the lens diaphragm, which reduces depth of field. A digital cinematographer will stop the lens down to control highlights, which will tend to accentuate depth of field. Thus, in digital cinematography, even with larger sensors, the need for controlling exposure in order to control and minimize depth of field has remained something of a challenge. As Jeff Cronenweth, who used the Red camera to shoot *The Social Network*, pointed out, "If filmmakers shooting digitally choose to use depth-of-field

as a storytelling tool, then it's imperative to control the exposure to control focus" (Goldman, "With Friends" 33). When the crew working on *The Social Network* shot outdoors, they had to stack ND filters on the camera to reduce the light, control the highlights, and enable the lens diaphragm to open up and produce shallow depth of field.

While filmmakers today continue to prize shallow, selective focus as a storytelling tool, digital cameras have complicated the pursuit of this goal by privileging an expansive depth of field, one that Bazin would have embraced for its realist potential. At the same time, digital cameras make long takes normative by eliminating the resource constraints that operated on filmmakers who shot on film. Film represented money running through the camera, so it was used sparingly and takes were kept short so that, if something went wrong, a ruinously expensive amount of film was not compromised. Furthermore, camera magazines were limited in what they could hold, which was around ten minutes worth of film.

When shooting digital video, your data goes to a storage device on a card, a drive, or the cloud, and how much you can store affects how long you can shoot. Bazin loved the way Jean Renoir followed his actors with a moving camera rather than cutting in films such as *The Grand Illusion* (1937). Renoir moved the camera to extend the

shots, and he felt the actors gave better performances this way. Bazin felt it was more realistic. The Japanese director Akira Kurosawa often used multiple cameras to extend the length of takes, reasoning that the actors gave better performances this way, as did Paul Greengrass on *United 93* (2006). On *Dog Day Afternoon* (1975), Sidney Lumet used staggered load times to keep the cameras running so that the actors could remain in the scene and in character for longer periods. Film directors who value the authenticity of performance, and the truth of the emotions being dramatized, found these ways of overcoming the predominant practice of using very short takes when shooting on film.

Digital video tends to normalize long takes. By removing the resource constraints of an expensive medium such as film, digital video gives filmmakers a new opportunity and a new ability to, as Bazin said, "analyze the dramatic field in time." Like deep focus, longer takes are an aesthetic choice, but they need not be incompatible with editing. A scene may be shot with long takes and multiple cameras—as Kathryn Bigelow did on *Zero Dark Thirty* (2012)—and then assembled as a montage for the screen. By privileging deep focus as well as long takes, digital video is not only compatible with but actually furnishes the spatiotemporal conditions of a Bazinian realism, and digital compositing enables filmmakers to make an edited

and highly fragmented assembly of materials look like a long, extended take.

In *Gravity* (2013), Ryan Stone (Sandra Bullock) is the sole survivor of a debris shower that destroys the space station where she worked and its crew. She finds temporary refuge aboard a damaged international space station. When Stone forcibly enters the ruined space station and fills an air lock with oxygen, she removes her space suit down to her underwear, relaxes, and drifts into a fetal position replete with a symbolic umbilical cord. The film's director, Alfonso Cuarón, holds on this fetal composition for a few beats because it is the first moment of relaxation for the character and for viewers after a very taut and peril-filled first act during which all of Stone's fellow crew members are killed.

The air-lock scene seems to unfold in a single, extended shot. In fact, the shot on screen is the result of compositing several takes, some of which were shot in a light-box set where actors were surrounded with LED panels and some on a partial, minimal set where Bullock sat on a bicycle seat mounted at the end of a pole to which her left leg was strapped (Fordham). Robotic machinery moved the camera, the key light, and a porthole to the air lock behind her, movements that established an illusion that the character is drifting in weightless space rather than being held stationary.

Clothing removal offered compositors opportunities for joining takes and for performing the routine editing task of cheating the action by removing unessential intervals in order to speed things along. The first transition between takes occurs as Bullock removes her helmet, with the visor providing a traveling matte, or digital wipe, to hide the transition. When she removes the top of her suit, the compositor transitions to another take, replacing some of Bullock's body with animation in order to facilitate the action. Briefly she is given CG arms so the suit can be gotten out of more quickly, her forehead is warped to make the angles work, and her left leg, which is strapped to the seat pole, is digitally replaced from this point until the end of the scene.

Thus, the poetics of motion that Cuarón pursued in portraying a zero-gravity world throughout the film extend as well to the long takes that seem to exist on screen. The apparent extensions of time and space in these long takes are representational but not existential. They are *portraits* of spatial and temporal continuity but are not *records* of such things. As in his earlier film, *Children of Men* (2006), the sequence shots are in fact montages, resulting from extensive and extended compositing. This is true throughout the film. The poetic drifting motions for characters that gimbal rigs and robotically controlled cameras help to create offered many opportunities for

creating digital montages composed of multiple takes that are made to seem like a single take. When a character drifts off frame or turns so that her or his face is obscured from the camera, compositors could use another take or use digital replacements to cheat the action by squeezing or stretching the actor's performance.

Bazin believed that long takes were inherently realistic because they preserved the wholeness and integrity of space that would otherwise be fractured by shot changes achieved through editing. Digital compositing provides filmmakers with new methods of achieving the representation of spatial wholeness using long takes that are real or simulated. In *The Revenant* (2015), the director Alejandro Gonzalez Iñárritu staged an Arikara attack on an encampment of fur trappers as a long sequence in which the action unfolds in what seems to be a single camera perspective. It was shot with three cameras, however, with digital compositing hiding the cuts. Iñárritu wanted to heighten the viewer's sense of being inside the scene, making it a more immersive experience. "I wanted to show one point of view to allow the audience to experience personally what it must feel like to be attacked in that way" (Goldman, "Left" 42).

The experience of immersion, vividness, and tactility can help to foster a viewer's sense of realism, that is, of the perceivable reality of the narrative world represented on

screen. While this may result in a stylized or poetic form of realism, what counts is a viewer's sense of its perceivable credibility. Accordingly, the last set of factors to be considered with regard to cinema realism involves what we see when we look at a film or a digital image. This question can be posed in terms of image resolution and luminance. How much information is present in the image? Many industry professionals feel that a 4K or 6K digital image, which is what high-end digital movie cameras capture, is comparable to 35mm film. Ironically, however, analog cinema throughout its history offered viewers significantly degraded images. In the photochemical era, the 35mm prints screened in theaters were three or more generations removed from the original camera negative. That negative would be printed to create an interpositive, from which a secondary negative—the internegative— was struck, and from this, the release prints were made for showing in theaters. Resolution was lost with each generation of printing, and if a movie were screened in a theater with a projector bulb that was dimming and losing luminance, a further loss of resolution would occur. There was always more information in the camera negative than could be recovered through photochemical printing, and digital technologies such as high-resolution scanning have enabled viewers at times to actually see more in a restored film output in a digital format than audiences

would have seen from a conventional print projected on film in theaters.

Because digital information is all ones and zeros, copies of digital images and movies are better thought of as clones, as exact duplicates, than a photochemically printed copy of a film would be. Copying and distributing a digital cinema image does not entail the step-by-step loss of image values that prevailed in photochemical cinema. Thus, digital images can offer a kind of hyperclarity and sharpness of detail. As the cinematographer of *Zodiac* said about the images captured by the Thomson Viper camera, "The audience will see more than what they normally see in a movie—literally, the pores on people's faces and every hair on their heads—so it may have an almost immersive effect" (Williams 41).

This kind of immersive effect can be a constituent of cinematic realism, of the sense of reality that a movie may evoke. Increased resolution and luminance values can evoke a heightened reality impression in the viewer, and digital imaging tools have given filmmakers new methods of capturing visual information and the ability to handle vast quantities of visual data. Our theories traditionally have linked analog photography—using film—to cinema's properties of realism. Film cameras, as we have seen, are said to provide direct evidence of what was before the lens, whereas digital does not because it

can be manipulated imperceptibly. Such theories, how-ever, have missed a crucial consideration pertaining to all cameras, which is that they are lossy instruments, incapa-ble of recording all of the luminance values in a scene or environment. A photographer must selectively sample a range of light values. By setting camera exposure, a pho-tographer necessarily excludes some visual information that is in the scene from being recorded.

But a series of photographs taken across a range of exposure settings, including under- and overexposure, can capture the full range of environmental light values. Digital imaging applications can merge the photographs to produce a single image that conveys all of the lumi-nance in the scene. The result is a high-dynamic-range (HDR) image, providing an environmental luminance map. Filmmakers use these in compositing images that merge digital lighting or other effects with live action or that require re-creating lighting and décor from a real scene inside of one that is composited or is virtual. HDR luminance maps enable filmmakers to work with all of the light that has been before their cameras.

Red's Epic camera, which David Fincher used to film his remake of *The Girl with the Dragon Tattoo* (2011), shoots at 5K resolution and made a significant step toward HDR cinema. It offered a shooting mode called HDRx that captured two video tracks simultaneously. One track

is the normal exposure as determined by the cinematographer, while the other is a highlight-protection track that uses a different shutter-speed setting to dial the exposure down by up to five stops, enlarging the total available exposure range to eighteen stops of light. In postproduction, the two tracks can be combined into one, enabling a filmmaker to dig into the shadows while preserving more detail in the highlights than a single exposure setting would permit. If one parameter by which we understand cinematic realism is the camera's ability to record the information present in front of the lens, then the advent of HDR cinema is a notable advance in recording fidelity, in achieving this constituent of realism.

HDR images expand the range of light values beyond what a camera can capture in a single exposure. HDR cinema amplifies the amount of information contained in the image, as do other parameters and tools of digital cinema. The virtual jungle environment in *Zootopia* contained hundreds of trees, which had millions of leaves in "huge and highly detailed jungle sets" (Melson), and digital tools provided a means for handling and displaying this data in real time to facilitate the effects work. *Gravity* featured a daunting amount of information and resolution in its computer animations. The matte paintings of Earth, for example, featured volumetric renders of urban lights glowing beneath cloud formations. A volume

render, treating the total space occupied by a 3-D object, is slower and more expensive than rendering a surface. And, in this case, volume shaders were used to calculate the ways light would pass through the varying densities contained in the volume of clouds, which contained billions of voxels, or volume picture elements. Nearly every shot of Earth involved some type of volumetric render, and this level of precision and detail extended to the other virtual objects in the film. The space shuttle *Explorer* was a hugely detailed model built from twenty-five million fully rendered polygons and was based on high-resolution photos of existing orbiters. For *Alien: Covenant* (2017), artists designed a city populated by engineers that was the size of Manhattan and designed fifteen thousand individual buildings in it (Edwards, "Dark").

Realism is a multifaceted, multicontextual category and concept. It encompasses issues of representation as well as style, and the two often merge. We cannot see the past except as it survives in physical artifacts and images. *Selma* (2015) dramatizes a three-month period in 1965 when the Reverend Martin Luther King Jr. and civil rights activists planned the historic march from Selma to Montgomery, Alabama. The director, Ava DuVernay, wanted the movie, which was shot digitally using Arri Alexa cameras, to look as if it were shot on Kodachrome film (Thompson). She liked the way selective colors

stood out in period photographs, shot by Paul Fusco on Kodachrome, from 1968 of Senator Robert Kennedy's funeral train and the crowds that gathered to view it as it traveled from New York City to Washington, DC. These photographs had the patina of historical realism that she wanted for her film. The look of Kodachrome furnished the marker of history.

The aesthetic and social objectives of filmmakers and the contexts in which images are created and circulate influence the degrees of realism attributed to them far more than whether they are photochemical or digital. At the same time, digital imaging provides filmmakers with newly enhanced abilities to work within established parameters of cinematic realism. Realism remains a foundational concept for understanding visual representation; people continue in the digital era to care very deeply about the meanings of the images they encounter and experience and to make discriminations about their veracity and degrees of truthfulness. This epistemological commitment to realism also makes possible the malignant effects of deep fakes: the digital simulation of reality in fake footage designed to be received by viewers as real and the corrosive effect on the social fabric that these are likely to have. At the same time, one must remember that cinema is as much artifice as realism, a magic show as well as a record of reality, and that the two things are

synergistic. As James Cameron has said about filming on a movie set, "When was it ever real? There was [a wall here] and nothing over there. There's thirty people standing around. There's a guy with a boom mike, there's another guy up on a ladder with his ass crack hanging out. There's fake rain. Your street night exterior in New York was a day interior Burbank. What was ever real?"

3

CHEATING PHYSICS

"Remember the first time you saw the characters defy gravity in 'Crouching Tiger, Hidden Dragon'?" Roger Ebert wrote in his review of *Spider-Man* (2002). "They transcended gravity, but they didn't dismiss it: They seemed to possess weight, dimension and presence." Ebert found himself unpleasantly distracted by the digital Spider-Man. He did not seem real, did not seem to comport with the physical laws of gravity or the mass and weight of a human body. "Spidey soars too quickly through the skies of Manhattan; he's as convincing as Mighty Mouse."

Writing about *Spider-Man 2* (2004), Scott Bukatman shared Ebert's response. The film is about a battle between Spider-Man and the villain Doc Ock, and Bukatman wrote, "Ock's mechanical arms can punch holes in the brick wall, holding him up with apparent ease, while Spidey's powers allow him to cling to walls. . . . The figures are, in many shots, entirely computer generated, and

the net effect is of some vaguely rubberoid action fig-
ures harmlessly bouncing each other around the space."
"Perhaps there's such a thing as being *too* weightless,"
he reflected and suggested that the main problem with
superhero movies is an unconvincing integration of live
action with computer-generated imagery (Bukatman,
"Why" 120). Because CG bodies are not real, they behave
inappropriately in relation to physical laws. "By remov-
ing the body from space, it [the superhero film] removes
meaning—lived meaning—from the body" (120). As Lisa
Bode writes about an animation aesthetic that contorts
human physical limits, "Bodies in such screen contexts
can become too plasmatic, lose their weight, their plau-
sibility, and their ability to make us believe and to make
us care" (192). Lori Landay suggests that in many digital
films, "the director minimizes the live-action portion of
filmmaking and shunts the rest into an environment less
constrained by physics" (133). She suggests, though, that
such films provide unique, special pleasures. "The plea-
sures of the digital are about transcending gravity, about
bodies exceeding their limits" (134).

Whereas Ebert and Bukatman lament the loss of a
realistically convincing physical environment in digi-
tally animated sequences, Landay suggests that this loss
might function more positively as a source of pleasure
for viewers. All agree, though, that digital tools have

enabled filmmakers to cheat physics in ways that could not be accomplished so readily in the analog era. Indeed, one of the challenges and problems with the digital tool-box available to filmmakers is its ability to blow past the constraints and limits that physical resources placed on filmmaking. Blowing through the material limits that constrained analog filmmaking can be a great temptation for directors, and this chapter explores some of the issues and consequences that can arise from this temptation.

When a director gives in to the temptation and asks CG artists to create something that has never been seen before, the results can be distracting and disconcerting for viewers in ways that pull them out of the filmic illusion. Visual effects artists themselves agree about this and place some of the blame on directors. The ILM animation director Rob Coleman, for example, says, "Directors are always asking animators to make CG characters do these physically impossible things—things that, in reality, would rip their shoulders out of their sockets." He continues, "When a character breaks the laws of physics, you are breaking the illusion. . . . [Viewers] are not going to believe that character is in peril. If he can leap 65 feet from one building to another, he is no longer like us, and we can't empathize with him" (Duncan, "State" 55). The visual effects supervisor Matthew Butler concurs. "When you have a non-fantastic shot, something that

has behavior and physical dynamics that the audience is well-educated about, then you've got to keep it dynamically real. . . . If you've got a guy falling off the back of the sinking *Titanic*, his center of gravity had better look right and he'd better be falling at a rate governed by the laws of physics, or else you've failed" (Duncan, "State" 68).

One of the problems that arise when physics are cheated is that viewers are skillful at detecting anomalies in physical movement. As Michele Bousquet points out, "When a character's motion or balance is a bit off in a way that's hard to pinpoint, the culprit is often a law of physics that's been violated." Empirical research has examined viewers' ability to recognize anomalies in the way that animated characters or objects move. Paul Reitsma et al., for example, found that viewers were readily able to detect problems in jumping movements by animated figures (Reitsma, Andrews, and Pollard; Reitsma and Pollard). These involved errors of acceleration and deceleration, in vertical and horizontal movement, and errors of gravity. Compounding the problem represented by the good eye of a viewer is that it can be computationally expensive to represent accurate physical laws in scenes with complex motion. As the ILM visual effects supervisor Eric Brevig notes, "It's expensive to run physics simulations on digital doubles and make them look as if they are really getting banged up [e.g., in a fight scene]. It's a lot easier just to

animate them the way you think they would probably behave—but that has a tendency to look wrong" (Duncan, "State" 55). Moreover, different animators may have different perceptions about what looks right, about how plausible a character's motion may appear.

Anomalies in representing ballistic motion (objects or bodies in flight), for example, are commonly found in movies. Physical laws are fairly inflexible. "Once the character has left the ground, the trajectory of the center of mass is fully determined. Any changes to that trajectory violate the laws of physics. Such changes can result, however, when motions with differing root velocities are spliced together, creating an anomalous acceleration, or when the effective gravitational constant changes as the result of an editing operation. An incorrect gravitational constant arises, for example, when the height of a jump is changed while timing remains the same. Scaling motion to characters of different sizes can also change the effective gravitational constant" (Reitsma and Pollard 538). Ari Shapiro and Sung-Hee Lee found large deviations in the representation of gravity across scenes. King Kong has regularly appeared on screen scaled at different sizes within the same film to enhance the dramatic impact of individual scenes. Scaling motion to a character's size, however, affects how fast that character can seem to move and its apparent mass and weight. It changes the way that

gravity seems to operate and presents numerous opportunities for getting things not quite right. When Kong climbs the Empire State Building in the Peter Jackson remake (2005), leaping from one section of the skyscraper to another, he moves too fast and seems too lightweight, as if he is minimally affected by gravity.

It is not that animators working in digital media are indifferent to these issues. It is that the issues are complicated, and their difficulty is compounded when filmmakers are overly tempted to finesse the laws of physics. There are times, though, when one needs to do this. An ongoing tug-of-war between art and science is under way, and it exacerbates the difficulties. Most visual effects artists agree that physics provides an essential foundation on which artistic designs—or cheats—can be erected. Geoff Scott, visual effects supervisor at Intelligent Creatures, points out, "The laws of physics always provide us with our foundation." James Reid, the head of effects at Milk VFX, says, "When designing an effect, it's important to find the right balance between realism and art. An awareness of the science behind natural phenomena is key to building something that's believable, even when dealing with magical effects." Ara Khanikian, visual effects supervisor at Rodeo FX, states, "I believe that if you create VFX [visual effects] using real-world parameters like gravity, weight, laws of inertia and momentum, and proper

lighting, it's easier to then dial in artistic liberties than if you start off by considering only the artistry." He points out, "Most feature film VFX work tries to replicate real-world physics and behavior. It's an on-going challenge to always produce photoreal effects, . . . but then again, what is photorealism? Is it what we see with our own eyes, or what we're used to seeing through a lens? The difference is a huge one" (Edwards, "Visual").

Photorealism in the latter sense—what we see through a lens—pertains to camera reality, which need not correspond with what an observer's eye would see when watching the scene staged for filming. The peculiarities of camera reality have always been an important constituent of cinema and have necessitated that filmmakers adopt special rules of filming when they wished to portray the laws of physics in a convincing or compelling manner. Filming miniature models, for example, required a different approach than what would be used with live action, so that models would appear to move with the same bulk, speed, and weight as their full-scale counterparts. The camera had to be much closer to the models than it would to their real counterparts; otherwise, they would not scale properly. The model would look lightweight and unaffected by gravity in comparison to its real counterpart. Depth of field was also a challenge: shooting at closer range necessitated using a smaller aperture or a shorter

lens so that the shots would appear to have a depth of field comparable to the normative focal range of full-scale shots. And because atmospheric perspective would make full-scale objects at some distance from the camera look hazy, this effect needed to be duplicated with the miniatures. Often these would be shot in a special room filled with the right amount of smoke. Frame rate also needed adjusting. A miniature in motion shot at twenty-four frames per second, the normal rate of sound film, would look exactly like what it was, a small, lightweight object. Filmmakers evolved a formula for calculating the proper frame rate. It involved dividing the dimensions of the full-scale object by the dimensions of the miniature model and multiplying the result by twenty-four. The outcome would be the needed frame rate.

These camera techniques simulated physical laws, represented and performed them instead of capturing physical reality directly. Simulating physics always played a role in analog cinema—in the case of miniature models, it is fake physics, imbuing objects with qualities that they do not in themselves possess, at least not as the camera seems to have seen them. Miniatures in water sequences—the ships in *The Sea Hawk* (1940) or *Ben-Hur* (1959)—were filmed with the camera close to the waterline because this made the model ships seem bigger and heavier. Faster frame rates helped to scale up small waves and make

them appear larger. Cheating physics, or finding ways to perform the appearance of physical laws, is an enduring element of cinema and has provided filmmakers with venerable sets of tools. What seems to have changed in the digital era is that these tools have become more extensive and nuanced. If sometimes this has tempted filmmakers to do too much or to take things too far, the difference between the eras is more quantitative than qualitative. Nevertheless, quantity can become quality when the change is large enough or pervasive enough, and many viewers today might feel that action films in particular have gone too far in cheating physics.

Filmmakers in the analog era used the camera to enact a performance of physics appropriately scaled to the dimensions of objects as represented in the story, and digital animators do likewise in cinema today. They are beset by similar problems when their calculations prove to be wrong or ill-advised. Miniature models in the analog era were rarely wholly convincing as stand-ins for life-sized objects. As the remarks by Ebert and Bukatman indicate, for some viewers Spider-Man's behavior in seeming defiance of gravity became a distraction from the story. Just as miniature models might present a flawed scaling of size, weight, and mass, so too might digital characters, such as the Navi in *Avatar* (2009). Barbara Flückiger writes that the presentation of the Navi as being much taller than

ordinary human beings led to difficulties in appropri-
ately scaling their movements. "The pattern of movement
changes in relation to age, height, and, most significantly,
mass. In fact the Navi often seem too light[weight], and
it is immensely difficult to perceive their height correctly
if no human characters are present for comparison" (19;
trans. in Purse 61).

Spider-Man's apparent weightlessness as he flits
around the steel-and-concrete canyons of Manhattan
likely resulted from a stylistic decision about how to
represent his human fly abilities, and if the results were
not credible for some viewers, this is not an uncommon
outcome given the photorealist basis of popular cinema.
Characters in 2-D cartoons can successfully defy gravity
without challenging a viewer's suspension of disbelief.
Tricked by the Road Runner, Wile E. Coyote can run
off a cliff and hang suspended in space while he slowly,
nervously gazes downward. Only when he realizes with
dismay what is about to happen does gravity seize him
and he falls. "Wile E. Coyote's inventions disobey the
laws of physics on a regular basis, but there's still enough
real physics for you to understand what's happening"
(Bousquet). Flamboyantly defying the laws of physics
can work splendidly in a cartoon world, but photoreal-
ism tends to anchor characters within a matrix of phys-
ical laws that viewers recognize as their own. It is easier

to finagle these than to wholly disregard them. Because viewers have a fine-grained sense of how objects behave in the physical world, animation must capture some amount of these observable features in order to remain photorealistic. Thus, "it [is] hard to animate without help from physics-based simulations. Objects like fluids, building debris, and cloth often require physics-based simulation to acquire the physical properties [needed] for a realistic look" (Sterner 11).

A creative tension exists between the physics of photorealism and the artistic visions and aesthetic preferences of filmmakers. These preferences may be rooted in story situations and genre or in distinctions between filmmaking modalities, such as live action and animation, but in either case, they tend to move beyond photorealism. Superhero films, for example, exemplify these tensions because the characters are beings (often human) with enhanced powers but who inhabit the same world as the film's viewers, setting up a contradiction. Captain America, for example, is an ordinary person with enhanced powers that give him the ability to leap from an elevated highway or some lofty floor of a high-rise and land on hard asphalt or concrete without suffering any physical damage. In *Captain America: The Winter Soldier* (2014) and *Captain America: Civil War* (2016), he confronts hordes of adversaries and engages in ferocious fighting that leaves

wounds on his face. If his skin can be bruised and torn, as the camera reveals, how is he able to leap from high places and land on hard surfaces without suffering any internal structural damage? In his fights, he moves with astonishing speed and strength and is often pulverized with massive blows delivered by adversaries and yet he never fatigues or is seriously wounded. Because the images aim for photorealism, the impossible physics on display in the character make for a paradoxical narrative. And as in *Spider-Man*, there are numerous moments when Captain America moves so swiftly, so smoothly, and so effortlessly that gravity, weight, and mass seem to vanish altogether. These are moments that skewer photorealism.

The contradiction between photorealism and the peculiar physics required by the superhero narrative is unique to cinema in that it arguably never arose in the more stylized graphical world of comic books. Since 2010, digital animation in cinema has moved toward increased photorealism in the rendering of light and surface textures. Whereas information about light and surfaces had previously been defined using more ad hoc, less precise procedures, the Hollywood industry has transitioned to physically based rendering (PBR), a means of depicting physically accurate information about the light sources and surfaces in an environment, of modeling real-world material and lighting profiles that observe appropriate

physical laws, such as the conservation of energy (i.e., surfaces cannot reflect more light than is incoming).

PBR consists of two components, luminance and reflection: "physically correct and consistent specifications for virtual luminaires in a scene, including emission profiles and geometric shape; and, physically correct definitions of the reflectance profiles used to describe the scattering of light at surfaces in a scene" (Schmidt et al. 225). The more precise and accurate these renders have become in their design of light and materials, the stronger they evoke a framework of photorealism in digitally built environments and thus the greater the challenge in finessing this materialism with stylized, artistic deviations from the photoreal. The problem has emerged with special force in the digital era because digital simulations of photorealism coexist with fantastic narratives or spectacular characters whose abilities are beyond human. The problem is particularly urgent in films where caricature or other stylizations are critical. "Unfortunately, physically accurate rendering is often not sufficiently expressive for the caricatured nature of animated films: though physically-based rendering may provide a great starting point, the challenge then becomes introducing controls necessary to obtain a desired artistic vision" (Nowrouzezahrai et al. 1). Disney's *Tangled* (2010), a retelling of the Rapunzel folktale, used non-physically-based rendering

to create a painted look to its images and for a scene "in which curvy beams [of light] from a character's chest slowly fill a room, creating intricate, non-physical lighting both volumetrically and indirectly on surfaces" (Nowrouzezahrai et al. 6). Non-physically-based rendering represents an alternative to Hollywood's image production. Just as SIGGRAPH conferences tend to highlight research and developments in photorealistic rendering, yearly NPAR (Non-Photorealistic Animation and Rendering) symposia emphasize techniques for generating imagery and motion that are expressive rather than photorealistic.

When viewers complain about the CG look of many films, cheating physics is often a root culprit. Ben Snow, a visual effects supervisor at Industrial Light and Magic, acknowledges that visual effects artists have learned to live with the accusations that their work "looks fake or looks 'too-CG.'" But "of course, we don't *want* our stuff to look computer generated. We spend most of our waking moments trying to get away from that" (1). Accurate physics-based simulations provide a means for doing so, for avoiding a fake, too-CG look, and yet these simulations often are mediated by camera reality, by the imperative to simulate the attributes of an image as caught on film. "With visual effects for film, we're really trying to produce *filmed* reality, or more correctly the view of the

world that is captured on film or another medium. And it's an important distinction" (Snow 1). Working on *Pearl Harbor* (2001), Snow and his team tailored the film's digital airplanes and digital environment to match with artifacts present in the filmed footage. "One of the things we noticed while doing the planes on *Pearl Harbor* was the way the highlights would flare out in the real footage." So they boosted the brightness values in their lighting map of the digital environment and added "an additional bloom to the hottest highlights in the composite—trying to reproduce what happened to them in the medium of film" (1).

But physics-based simulations often provide only a foundation for the artistic visions or designs that are mapped onto them, and this is where problems can arise. As the head of effects at MPC Montreal notes, "A lot of the time real physics doesn't actually achieve good results. CG artists often need to cheat by reducing gravity or changing its direction, adding forces to get a plume of smoke in the right position, or manipulating the way explosion debris flies towards the camera or past an actor" (Edwards, "Visual"). Erik de Boer, an animation director at Method Studios, points out that understanding the laws of physics is essential for their work, but often those rules need breaking for reasons of drama or artistry. "Maybe the top speed of an F-16 feels too slow

relative to the camera and makes the shot a bit boring. The way an animal's limb changes shape when it meets the ground might need to be exaggerated, or its fur might need extra overlap to show a violent percussive impact" (Edwards, "Visual").

Gravity (2013) depicts the catastrophic destruction of a space station and the efforts of the sole survivor, Ryan Stone (Sandra Bullock), to reach safety and return to Earth. In various scenes, she clings to a violently spinning robotic arm on the Space Shuttle and slams bodily into the solar panels on the International Space Station. All of these actions were exaggerated to a point of physical extremity well beyond what the human body could withstand, despite the film's overall stylistic aim of conveying an authentic sense of how it would feel to be in a zero-gravity environment. The filmmakers felt that exaggerating what a human body could endure was essential for the film's dramatic impact. "In reality, the G-force she would have experienced while attached to the end of the Canadarm would probably have made her head explode, and when she slams into the solar panels on the ISS at sixty miles an hour, . . . well, you've seen car crashes!" (Edwards, "Visual"). Although the film aims to evoke Stone's perilous situation of being stranded in an environment hostile to life and to depict her as an ordinary person, the pummeling and pounding that she undergoes

subvert the photorealism that the film's visual effects have aimed to achieve. Her physical punishment, endurance, and eventual triumph fail to remain reliably within a recognizably human realm. Digital tools make it easy to exceed this realm, with the unfortunate effect of risking viewers' emotional involvement with the character.

The visual design of *Gravity* cheats physics in other ways. Stone uses a jet pack to travel from the Space Shuttle to the International Space Station and from there ventures to the Chinese space station Tiangong, an improbable feat given that they are in different orbits around Earth (Plait). Despite this fact, the ISS and Tiangong are visible in the film on a common sight line. The director, Alfonso Cuarón, and cinematographer, Emmanuel Lubezki, aimed to capture the physics of drift and weightlessness in a zero-gravity environment, and they used robotically controlled cameras pivoting around the actors, who played the scenes from positions on a variety of movable gimbal rigs. The camera was mounted to a mechanism that enabled it to pivot, spin, and move vertically and horizontally, while the camera rig itself could move along a ten-meter track. Lights and portions of the set could also move around the actors, who remained seated. Thus, numerous motions were simultaneously possible—of the actors, lights, and décor. These created the motion-perception illusions necessary for the film's

poetics of motion. These poetics aimed to erase the distinctions that gravity and a fixed horizon establish—up, down, left, right—and that the rules of continuity filming and editing work to establish and sustain in narrative film.

When debris hits the Hubble telescope, for example, Stone becomes untethered and tumbles helplessly in space. Sandra Bullock sat in a gimbal rig that spun her on a vertical axis and rocked her back and forth at a forty-five-degree angle. A robotically controlled key light circled around her, and these spinning and drifting movements, augmented with key frame animation of the character and by a digital matte painting of Earth rotating into and out of view, create the impression that she is tumbling end over end, a movement that the actress never performed. Some of this action was also filmed in a "light box," where Bullock was surrounded by LED panels illuminated with a video feed containing the physical environment of the scene shown from the character's point of view. The video enabled actors to see the settings that would surround them in the digital environment and that would be established in the final composite. These included matte paintings of Earth or 3-D modeling of the Hubble Space Telescope. The LED projections threw their light and color onto the faces of the actors, helping to map the live actor inside the digital world (Fordham).

These methods of achieving a portrait of zero gravity are brilliantly imaginative and effective, and yet Cuarón does not extend them consistently, perhaps because they tend to subvert the stable space-time coordinates of a more conventional narrative structure. He cheats the physics of zero gravity by imposing the familiar coordinates that gravity establishes—a stable ground plane and a fixed horizon line. When Stone and and her coworker Kowalski are low on oxygen and become tangled in webbing on the exterior of the International Space Station, Stone dangles in space, tethered to the station by a cable encircling her foot. Kowalski dangles from a line gripped by Stone with one hand. Cuarón films the action as if they are mountain climbers and Kowalski is hanging dangerously over a precipice, kept from falling by Stone's grip on his line. The camera alternately looks up at Stone from a low-angle vantage and down at Kowalski from a high angle. The actors' eye lines mimic this directional orientation—Kowalski gazes up at Stone and she down at him. None of this gravitationally defined directionality should apply in the story sequence. The filming style reimposes conventional perspective on the zero-gravity world of the story, and when Kowalski lets go of the rope, he falls rapidly downward in space as if gravity were pulling him to his death, consistent with Earth-bound experience.

Doctor Strange (2016) is more successful at harmonizing the physically real and the cheated, using the existing laws of physics to depict physical domains that do not exist. The title character is one of the Marvel superheroes, and the film is his origin story. Steven Strange (Benedict Cumberbatch) is a successful but arrogant surgeon whose hands are maimed in a car crash. They cannot be repaired by conventional medicine, so he journeys to Nepal and trains with an ancient sorceress who shows him the multitude of universes that exist beyond and apart from our time and space. She thrusts the doubting Strange through a series of these bizarre universes in a sequence the filmmakers fancifully termed "The Magical Mystery Tour." Strange drifts through a series of hallucinogenic worlds consisting of bright lights and colors, vortexes, fiery eruptions, and strangely organic, vegetative forms. All are abstract and yet familiar, with tangible physical textures that played an important role in grounding these bizarre domains in something viewers would recognize as real. The visuals were modeled from electron microscope photography of cells and microorganisms. The film's director, Scott Derrickson, said, "My biggest concern throughout the making of this movie was that we weren't creating real things through visual effects. We were creating things that didn't exist. Making those things feel like they were real to an audience was the biggest challenge. . . . It all

came down to physical textures that an audience could identify with" (Duncan, "Mirror" 72). Doug Bloom, one of the film's visual effects artists, pointed out why the microelectronic photography worked as a template for the sequence's visionary depiction of nonexistent realities. "By relying on micro-photography, we were able to develop images that looked very abstract, but were still physically plausible. At a subconscious level, you recognize it as something that actually exists—just at a different scale or in a different environment" (Duncan, "Mirror" 81).

The sorceress inducts Strange into another of the film's consciousness-expanding domains, the Mirror Dimension in which the existing physical world can be warped by the powers of sorcery without altering the actual world. A major action scene involves a chase and battle between Strange and the film's villains in the Mirror Dimension. The buildings and streets of Manhattan, where the battle occurs, are warped and transformed kaleidoscopically as fractal formations. Fractals are a class of objects that show the same structural features when viewed at any degree of scale, a property of self-similarity. They show up as numerous forms in the natural world—snowflakes, islands, river networks, shorelines—and in such shapes are organically familiar to audiences. Loren Carpenter first demonstrated the power of fractal animation for

visual effects in film when he exhibited his short movie *Vol Libre* at the 1980 SIGGRAPH conference, and he had been inspired by the mathematician Benoit Mandelbrot's book *The Fractal Geometry of Nature*, in which Mandelbrot argued that mathematical formulas underlay many organic, natural forms that had been dismissed by conventional geometry as formless (Prince, *Digital*; Mandelbrot). Because each part of a fractal is structurally like the others, it can be recursively subdivided to alter scale or create new objects, which is what happens in the film's Mirror Dimension sequence as buildings and streets fold up on one another or subdivide to form new constellations of urban metropolis. The transformations look weird, and yet their fractal nature makes them seem orderly and possessed of an underlying logic that audiences can recognize at a biological level.

By avoiding existing visual clichés often used to evoke magical realms and rooting these domains instead within existing natural forms, the filmmakers lent them a degree of plausibility that audiences could instinctively recognize. Concrete textures and organic natural forms grounded the film's fantastic domains in existing physics, establishing a degree of credibility in the story situations that would otherwise have been lacking. At the same time, the enhanced photorealism that physically based rendering has brought to contemporary film has

made it more challenging to introduce the deviations from physics that narrative situations or visual stylization might introduce.

Beyond the ability to cheat physics within photorealistic renderings of material environments, digital imaging tools have allowed filmmakers to cheat physics within the apparatus of cinema itself. Movies differ from theater in that they provide viewers with a mobile point of view, one that varies across shots because of changing camera positions and within shots due to camera movement. When working with physical equipment in the analog era, filmmakers were constrained; the equipment limited what they could do. A moving camera might travel along a set of tracks, but these would be finite in length. The same limitations prevailed with cranes: the camera could travel through space until it reached the end of the crane arm. The Italian director Sergio Leone loved riding the camera crane. In *Once upon a Time in the West* (1968), he designed a shot in which the camera travels with a character at ground level until she enters a telegraph office. The camera gazes at her through a window and then booms up the side of the building and across the roof to reveal an entire town on the other side. The reveal is striking and makes the shot very ostentatious, but the camera cannot extend beyond the crane's capabilities. Camera equipment imposed physical limits on filmmakers and set constraints

and boundaries on the mobile point of view that movies might offer their viewers.

Of course, filmmakers found ways of finessing these constraints. In the Hollywood era, optical printers could modify and extend live-action footage. Moving the printer head toward the camera, for example, could create the impression of camera movement. Linwood Dunn, the head of RKO's photographic effects department, used it often in this fashion. A famous shot occurs in *Citizen Kane* (1941) when the camera moves across a nightclub rooftop (a miniature model) and seems to travel through its skylight and continue moving down to the floor below (a full-scale set). As filmed, the scene consisted of two shots that Dunn joined using the optical printer and a lightening effect to hide the join. On *Bound for Glory* (1976), the cinematographer Haskell Wexler sat in a crane filming with a Steadicam. He rode the crane to the ground, stepped off, and walked through a crowd of actors in costume as characters, getting a handheld moving-camera shot. On screen, the effect seemingly dissolved the normal physical boundary of a crane shot. Instead of ending when the crane move stopped, the shot continued with the camera in continuous motion. The effect was electrifying.

Digital environments employ a virtual camera. Its movements are totally unconstrained; it can move anywhere, do anything, completely unfettered by physical

factors. It can dart through the tiniest openings and fly about through space like Spider-Man or Superman. The opening shot of *Poseidon* (2006) features an acrobatic camera executing a variety of moves that could not be accomplished with physical equipment in a single take. It begins underwater looking up at the outline of the giant ship *Poseidon* on the ocean above. Then it moves up, breaks the surface of the water, and moves around the front of the ship while filming at the waterline, the way that a miniature model on water would have been shot in the analog era. The camera seems as if it is mounted in a small boat on the surface of the ocean. Then it seemingly booms up, high up, and moves along the upper decks of the ship as if in a helicopter shot. The forced wide-angle perspective on the digital ship emphasizes its massive size. Then, still in motion, the camera descends to the deck and travels with a man jogging in what looks like a conventional tracking shot. But then as the jogger ascends stairs to a higher deck, the camera floats up the stairs in front of him, flies back into space as if in a helicopter shot, travels the remaining length of the ship, crosses behind it, and circles back to the top deck and the jogger, pirouettes around this character a few times, and then flies off away from the ship and toward the horizon, which is rendered as a digital matte painting where the morning sun casts a golden light.

Very little is physically real about this shot; everything except for the jogger is constructed as a digital environment. This kind of ostentatious, unfettered-by-physical-reality camera move is extremely common in popular movies today. A dramatic pullback in *Les Miserables* (2013) begins on a set depicting a student uprising against the monarchy in Paris in 1832. The camera starts on the film's main character, Jean Valjean (Hugh Jackman), and booms up to the height of the set (about thirty feet), then becomes a digital extension in a progressive pullback that reveals the extent of a huge Paris slum where the student barricades are located and the French army is poised to attack them. At the end of the pullback, the live-action set occupies only 5 percent of the frame, with everything else being a digital environment (Duncan, "Barricade" 23). It is a virtuoso effect but an impossible camera move in physical reality, and audiences probably recognize it as a digital construction that has been superimposed on the live-action elements of the scene. The elaborate expansion of camera perspective is ostentatious and calls attention to itself, emphasizing the style and the digital design.

When King Kong climbs the Empire State Building in the Peter Jackson remake and is attacked by airplanes, the camera swoops freely through space, up, down, toward the building, then pivots around it with exaggerated perspective information to enhance a vertiginous sense in the

viewer of plunging through space. The perspective rota-
tions in these kinds of shots are enhanced and excessive,
which pumps up the sensation of being liberated from
earthly constraints. (Numerous examples can be found
in the *Lord of the Rings* films.) Lisa Purse writes about an
earlier shot in the film where the camera makes a sweep-
ing, circular move around the ship, heading for Skull
Island, as it leaves the New York harbor. "The camera
traces a large curved path around the ship in an extended
fifteen-second take. . . . But lack of literal motivation for
the expansive mobile framing also lends this shot of the
ship leaving port a showy exhibitionism; it is a moment at
which the film seems to delight in the possibilities of the
digital" (84). Alternatively, one might say that it is one of
those moments when a director succumbs to the digital
temptation of leaving finitude behind.

Other ways of overcoming the optical limits of analog
filming include digitally altering the expressive character-
istics of lens optics or the luminance values or distribu-
tion of light as captured in camera. As we have seen, digital
tools enable filmmakers to place camera artifacts within
digitally rendered environments. These may include lens
flares, film grain, barrel distortion, and other rudiments of
camera perspective. Beyond being added to a scene, they
can be digitally transformed in ways that go well beyond
the possibilities of existing camera optics. In *Speed Racer*,

the Wachowski sisters created numerous effects that they regarded as faux lensing, impossible camera views, such as compositing numerous planes of space to create an exaggerated deep-focus perspective. In other shots, they altered a rack focus so that changing the camera's focal plane midshot to bring a background character into focus did not entail losing focus on the foreground character. Although *The Revenant* (2016) was filmed in natural light, during digital grading, the footage was extensively altered to highlight characters or to create directional key lights on faces for emphasis. This was accomplished by hand animating mattes to follow the contours of the actors in motion and altering their luminance values. Of course, these alterations were not in harmony with the production goal of relying on available light to film scenes.

Just as the mobile point of view in digital cinema can cheat physics in elaborate ways, it can do so by transforming multiple mobile points of view into what appears on screen as a single, extended, unbroken unit of time and space. In chapter 2, we saw how digital long takes in *The Revenant* were intended to serve the film's overall style of naturalism and to immerse the viewer into the film's action, particularly during the early sequence in which Arikara warriors attack the traders' camp. What seems to be one extended traveling-camera shot was composited from forty individual shots, using character and

object motion or lens flares as mattes to block the joins or using digital matte paintings to match different takes or even by warping selective features of the landscape to facilitate a join. A sequence later in the film in which the trapper Hugh Glass (Leonardo DiCaprio) is attacked and mauled by a bear is conveyed in an extended six-minute take that was composited from sixteen separate shots that were stitched together (Duncan, "Into the Wild"). Just as cameras making impossible physical moves have become familiar features of popular film today, so too have these elaborate extensions of apparently unbroken time and space. The James Bond film *Spectre* (2016) opens with a four-and-a-half-minute shot in which the camera follows Bond and a companion as they walk through Mexico City amid an exuberant crowd celebrating the Day of the Dead. A hidden optical transition occurs when they walk into a hotel, and another transition occurs when they enter a room in the hotel, which was actually a set in London. A last transition occurs when Bond steps through the window onto a ledge outside the building (Edwards, "Explosive"). Numerous digital fixes were required to hide the transitions and match elements in each of the shots so that everything would seem to occur within the interval of a single take.

In the analog era, the use of a long take or sequence shot offered a clear alternative to the normative practice

of shooting for continuity editing, in which a scene was broken down into constituent elements that were assembled during editing to create an orderly flow of shots. Long takes broke with the tradition of continuity editing, and they were risky because if something went wrong, an entire scene might be ruined. Today digital characters as well as the camera itself can be untethered from physical limitations. The digital long take can be as virtual as the unfettered camera and can be as subversive of the physical limitations that governed cinema's apparatus in the analog era. Challenging physics, though, remains a delicate undertaking requiring intelligence and finesse because viewers can be unforgiving when they come to feel that a digital character on screen, or a virtual camera, is showing off in ways that fail to honor the physical or storytelling principles that ground a film's narrative. Moreover, cheating physics can result in paradoxical narratives in which a character's abilities may vary in ways that clash with the detailed photorealistic rendering of spatial environments that is typically found in films today.

Digital tools have opened new vistas for filmmakers, and some filmmakers have rushed exuberantly to embrace the creative possibilities of liberating characters and the camera from physical reality. But in art, constraint and limitation are productive—by challenging an artist, they foster creative solutions. An artist does not really

want total freedom because creativity flourishes when it faces and must solve problems. Throughout cinema's history, the constraints of budgets, resources, and equipment have compelled filmmakers to make interesting stylistic choices. Digital filmmaking in this respect resembles work in the analog era—it flourishes when artists respect constraints. In a narrative mode such as cinema, viewers often look for them to do so.

4

BEYOND CINEMA

Throughout the history of cinema and in its most popular modes, it offered its viewers representational spaces depicting narrative worlds with unparalleled sensory immediacy. No other medium came close to cinema's ability to create an illusion space that was visually and acoustically enveloping, sensually persuasive, and perceptually credible even when its narrative worlds were plainly imaginary. Until now. A new mode of moving pictures beckons viewers to step inside an optical experience that is bodily enveloping and generates a sense of presence that is more vivid and persuasive than what cinema has offered. This is the mode of virtual reality (VR). It builds on many of the advances in digital imaging and computing that have nourished contemporary cinema but repurposes them to create imaginary worlds that have a visceral and concrete presence going beyond cinema. These advances include the processing power and image resolution needed for generating the live streaming

of real-time computer graphics, simulating a three-dimensional world responsive to a viewer's movements in it. And they include the gyroscopes and motion trackers honed by a generation of smart phones, repurposed to create VR illusions. Whether VR will catch on in a big way with a broad base of users or will remain a niche product and experience remains to be seen, but for the first time in its history, cinema faces a mode of motion-picture experience that surpasses it by taking viewers *inside* an optical world and inviting them to experience and explore it in direct and interactive ways. VR builds on the heritage of immersive art and entertainment that spawned cinema, and yet it moves beyond cinema in fulfilling the implicit promises of that heritage. Let us begin by tracing some of this context.

Cinema's history of technological innovation carried the medium toward ever more vivid illusion spaces. As Robert Neuman, a supervisor of stereoscopic film production for Walt Disney Animation Studios, has pointed out, cinema "has had a history of innovations that tend toward higher and higher degrees of immersion." These include refinements in film grain, image resolution, and display capabilities; the advent of color cinematography; expanded and reconfigured screen sizes accentuating the role of peripheral vision in the spectator's experience; the advent of synchronous sound, then of multichannel,

spatialized sound, and now uncompressed, lossless sound formats; the shift from photochemical lab timing and printing to digital grading; the advent of digital visual effects; and the shift from optical to digital compositing.

The use of digital tools for visual effects brought new levels of perceptual realism and credibility to what, in the analog era, had been somewhat more awkward and certainly more visible joins between the live-action elements of a scene and what were then termed special photographic effects. Because effects elements were stacked and photographed in the optical printer as layers to produce a final composite, the outcome was a planar rendition of visual space. Live action was visibly separate from the effects elements, and the z-axis—the zone of space extending through the image from near to far—often could not be effectively choreographed as an active element in shot and scene design. Noel Carroll's description of *King Kong* (1933) addresses this tendency. "The space of many of the shots sporting battling, back-projected behemoths in the background and tiny humans in the foreground seems curiously disjunct. The monsters inhabit tangibly different spatial zones than the humans" (*Philosophical* 135). Digital compositing enabled a more precise and thorough integration of live action and effects and permitted filmmakers to achieve a more volumetric rendering of space in shots conjoining these elements.

When the T-Rex appears in *Jurassic Park* (1993) and chases the paleontologist Alan Grant (Sam Neill), Grant runs toward the camera with the T-Rex behind him, thundering ever closer, while the camera pulls backward through space. Movement by the real, physical camera, by the virtual camera, by the live actor, and by the CG creature flows dynamically and seamlessly along the z-axis, producing a kinetic charge for the viewer that would have been extremely difficult to achieve in the analog era.

Z-depth mapping enabled digital compositors to control and choreograph more complex movements within a composited shot; the analog era had no counterpart to such mapping. Digital imaging tools have evolved so that now every pixel within a live-action shot can be mapped in relation to its position in space. Lytro Cinema is a camera, server, and software system for capturing and processing light fields and almost certainly represents the future of professional cinematography. Conventional cameras record an image from the standpoint of a single lens, whereas the Lytro camera employs an array of microlenses that map each pixel with regard to its color, its directional properties, and its placement in three-dimensional space. This enables the Lytro to become a virtual camera analyzing space rather than a conventional camera translating a 3-D scene into two-dimensional space. Computer graphics are three-dimensional, whereas cinema's cam-

eras have translated the world into a planar projection. This disjunction has made it a challenging endeavor to integrate CG elements with live action because computer graphics are 3-D whereas a film output is 2-D. The Lytro camera overcomes this division.

Processing light-field data captured by the camera in shots and scenes, a cinematographer can focus on any area within a shot, create any aperture or depth of field, any shutter speed or frame rate, and move the camera into or out of the scene, to the left or right, just as if these were creative decisions made on set during filming. Stereo-scopic movies can be produced using the single camera because it can generate left-eye and right-eye views with-out the need for a dual camera rig. Because every object in a scene has positional information in space, live-action and CG elements can be conjoined without the need for green- or blue-screening. Matte extraction becomes effortless. "To be able to pull a matte from depth alone and selectively include or remove objects in a scene based on their depth value was truly empowering," wrote the cinematographer David Stump about his experience using the camera. He continued, "The visual-effects art-ists found the ability to derive an alpha matte solely based on depth, and to separate objects without having to deal with any green- or blue-screen spill, to be revolutionary" (Stump 76, 77).

Lytro Cinema's heightened abilities to process and shape the array of information within a field of light provide filmmakers with next-generation capabilities, ones that probably will become standard parts of the imaging toolbox. Even if cinema remains a planar projection on a flat-screen display, its image production will have been fully volumetric. This refinement holds with the overall trajectory of technology in film history, which is to provide more compelling visual illusions. André Bazin referred to this impulse as the myth of total cinema. He wrote that the inventors of cinema aimed to create "a total and complete representation of reality, . . . a perfect illusion of the outside world in sound, color and relief" (20). Until VR, cinema was unparalleled at accomplishing this.

To be sure, there are alternative modes and practices of filmmaking that aim to deconstruct, minimize, or dispel the medium's incantatory power to construct an illusion space, and the concept of "illusion" has enjoyed little respect in the critical discourse on cinema. And yet it is clear that immersive illusion spaces have played an ongoing and recurrent role in art history and that the pursuit of perceptual immersion by artists and audiences connects cinema with a long artistic heritage. Arthur Grau examined the history of visual arts that aimed to maximize a viewer's sense of being in the picture, rather than standing outside it, and he concluded that these efforts were a

fundamental part of art-making practices in the Western world. "Virtual reality forms part of the core of the relationship of humans to images. . . . In each epoch, extraordinary efforts were made to produce maximum illusion with the technical means at hand" (5). For Grau, artworks and media as diverse as the Great Frieze in the Villa Dei Misteri at Pompeii (circa 60 BC), Gothic cathedral ceilings, nineteenth-century panoramas, and cinema have aimed to overcome the spectator's sense of being outside the experience and aware of its edges and borders. About Gothic cathedrals, Allison Griffiths points out that the heightened sense of immersion produced by their architecture and artwork was an essential part of the overall religious experience they sought to induce (18).

Before the invention of cinema, panoramic paintings and photographs offered spectators an illusion space scaled so that they seemed to enter physically into it and, in some cases, even to be able to move about inside it. Robert Barker's *Grand Fleet at Spithead* (1794) surrounded viewers with an enveloping, 360-degree painting, displayed in a specially constructed building in which they could walk through and around the panorama, immersed in its epic portrait of the royal fleet and freed from the static viewing boundaries of traditional painting. Some panoramas placed real objects between viewers and the image to accentuate a sense of depth and to

enhance the experience of motion perspective as viewers moved inside the panorama. About Anton von Werner's 1883 panorama *The Battle of Sedan*, Grau writes, "The faux terrain, the three-dimensional extension of the one-dimensional picture, had the function of integrating the observer, it came up close to the spectators, particularly in the section where hand-to-hand combat was depicted, and this strategy of virtually removing boundaries led, or rather pulled, the observer into the depths of the image space" (106).

Anamorphic images, panoramas, and stereoscopes pre-dating cinema aimed to move beyond the static boundaries of linear perspective and to capture the perspective effects of enhanced depth, parallax, and motion. With cinema's moving images and flexible, mobile point of view created by changing camera positions, it became the natural inheritor of this long-standing artistic and cultural interest in virtual realities. It became the perfect medium for inducing what Richard Allen has termed "projective illusion," experiencing "a pictorial or dramatic representation as if it were a fully realized world of experience and not a representation" (82). Because cinema embraced narrative, it was able to extend this experience for viewers across time and space, and its series of technological innovations worked to enhance and intensify the experience. Cinema arguably has provided the most intense and

vibrant experience of projective immersion into a narra-
tive world among any popular medium, until now.

Projective immersion can be understood as a synonym
for what we now call, in its most intensive manifestation,
virtual reality. The digital revolution that gave so much
to cinema has shifted the experience of immersion, at
its most enveloping levels, away from cinema. As a con-
cept, a theory, and experimental medium, VR is not new,
but computer technology has extended its experiential
promise. Indeed, in its contemporary sense, virtual real-
ity contains two essential attributes: it is immersive to the
point that it fosters a sense of physical presence, and it
is interactive. Wearing a head-mounted display (HMD)
that presents paired stereo images to a viewer's eyes and
carries stereophonic sound, the viewer makes entry into
a projective illusion that is enveloping and that the viewer
can alter by choice or action. Motion-tracking sensors in
the HMD respond to the viewer's head movements and
modify picture and sound accordingly, so that moving
one's head produces a corresponding change in the opti-
cal and acoustical array. This elicits a bodily sense of being
inside the illusion. Data gloves, touch pads, or game con-
trollers enable physical inputs to the virtual world so that
a viewer can seem to touch its objects, move them about,
or otherwise interact with them. While cinema has aimed
for immersion throughout its history, it is interactivity

that separates contemporary VR modes and media from cinema. And as we will see, this has ramifications for cinema's popular role as a narrative medium, as a storyteller, and these factors may limit cinema's ability to embrace virtual reality.

The use of modern technology to induce a VR experience dates from the 1960s (Gutierrez, Vexo, and Thalmann 4–6). Morton Heilig was a cinematographer who is often regarded as the father of VR because of his 1957 invention, the Sensorama Machine. It was a kind of viewing booth into which one placed one's head, and it simulated the virtual illusion of riding a motorcycle or flying in a helicopter, using stereoscopic film and sound, along with smell, seat vibrations, and wind in the hair. Morton also patented in 1960 the first head-mounted display, which he called the Telesphere. In 1961, Philco Corporation manufactured a helmet with a video screen and head-tracking sensors, and in 1968, Ivan Sutherland created an HMD with stereo optics and head tracking. (Sutherland was also a founding pioneer of computer graphics who invented a graphical user interface and a light pen that enabled the user to create drawings directly in a computer; see Prince, *Digital* 15–16.) In 1978, researchers at MIT created the "Aspen Movie Map," which used photographs of the city to enable users to take a virtual ride through Aspen and determine in which directions

they wanted to travel. The first wired data glove moni-
toring hand movements appeared in 1977; a decade later,
Nintendo offered a Power Glove for use by video gamers.
Sega introduced wraparound VR glasses in 1993.

But it was in recent years that VR expanded dramati-
cally as a home entertainment medium, driven primarily
by the video-game market. (Prior to this, VR had been
used extensively for training purposes by the military and
in aviation and medicine.) Oculus VR formed a Kick-
starter campaign to fund the development of its Oculus
Rift VR headset, and two years later, before the headset
had been released, Facebook purchased the company for
$2 billion. Facebook's founder and CEO, Mark Zucker-
berg, described VR as the future of computing and social
media and said the purchase was a long-term bet on VR
as the next major platform. He said, "Imagine enjoying
a courtside seat at a game, studying in a classroom with
students and teachers all over the world, consulting with
a doctor face to face, or going shopping in a virtual store
where you can touch and explore the products you're
interested in just by putting on goggles in your own
home" (Orland, "Facebook"). The Facebook purchase
was a major vote of confidence in the future of VR. Early
on, Sony moved to dominate the consumer entertain-
ment VR market because of its huge installed base of Play-
Stations and a relatively low price point for a PlayStation

VR upgrade. Google Daydream and Cardboard, Samsung Gear, and HTC's Vive headsets are other major players in the home and mobile VR market, and Google also makes Jump, a high-end camera for VR filmmakers that facilitates the stitching of multiple video streams needed for producing 360-degree films.

Many 360-degree films are not true VR. They can be viewed on cell phones or desktop computer video players using a mouse or touch pad to shift the view anywhere within the spherical space. Doing so, however, the viewer remains outside the video experience, which is not fully interactive since the viewer's input and decisions do not alter the sequencing or outcome of events in a film. This condition of limited interactivity remains true even if the 360-degree film is viewed with a headset. With true VR, the viewer is inside the optical experience and can influence its course of events through choices and decisions about what to interact with and how.

VR intersects with cinema but, at present, is not quite cinema, at least not in the way the older medium operated as a moving image viewed on a two-dimensional screen and capable of being viewed singly or in groups. Unlike the collective nature of cinema with its pubic screenings, VR currently tends to be a relatively isolating experience, requiring a headset that cuts off the spectator from other people and viewers. Movies grew up as a mass medium,

a social experience based around shared emotions that bonded individual viewers with one another. VR headsets go in the other direction, toward a cocooning kind of experience. The VR designer Fabian Giesen posted a polemic in which he asserted that "the endpoint of VR ... seems to be fundamentally anti-social, completing the sad trajectory of entertainment moving further and further away from shared social experiences" (Orland, "Doom"). The *Doom* cocreator John Romero stated that VR in its current form "encloses you and keeps you in one spot. . . . Maybe in the future there will be a better VR that gets you out of isolation mode" (Orland, "Doom"). On the other hand, as we will see, many proponents of VR see it as a medium to enhance viewers' empathy.

3-D Blu-ray and television failed in the home marketplace because of the requirement to gear up with special viewing glasses, and VR headsets may prove to be a similar kind of obstacle to the format's cultural diffusion. But many observers predict that it would be a mistake to assume that the clunky headsets of today will define the future of VR. Ollie Rankin, the head of production at Uncorporeal Systems, states, "It's wrong to assume that the virtual reality headset is the final viewing platform. I think the headset is kind of like the laser disk—something that was, at the time, the best way of storing and playing back video but was superseded quite quickly" (Edwards,

"Future"). The cinematographer Robert Stromberg sees a future in which the technology will become more invisible and favorable to social interaction. "The equipment will get refined, smaller, sexier. Then there's the social aspect—the option to experience something where you can look over and see your friend, like you do in a movie theater. I think that's all going to become very standard" (Edwards, "Future"). IMAX and AMC Theaters are developing VR centers that unite the public experience of theatergoing with immersive VR experiences (Barnes).

But, as noted, while VR shares cinema's objective of providing an immersive illusion, it takes this in different directions, suggesting that it is a wholly different medium. Aruna Inverson, a creative director at Digital Domain, points out, "Virtual reality is a new medium. It's not cinema, it's not television, it's not the internet—and those are the three main consumption modes that people have right now" (Edwards, "Future"). Cinema evolved into a highly efficient and effective medium for storytelling, and its stylistic history can be understood as refinements to the methods of storytelling. The mobile point of view, achieved through changing camera positions, editing, and camera movement, enables filmmakers to reveal and relate story information in strategic ways and to concentrate the viewer's attention on salient narrative details. Lighting, sound design, and depth of field, especially the

use of shallow focus, also work to highlight story information. These stylistic elements collectively establish a narrative point of view that tends toward an expansive third-person perspective, although narrow character viewpoints can be implicitly suggested or, usually for short intervals, literally portrayed.

The logic of cinema's narrative impulse required that filmmakers would aim to control what viewers looked at on screen so that key story information would not be missed. The spectator's lack of interactivity with the medium required the director and cinematographer to decide what would be in the frame, what the camera would be looking at moment by moment and how shot changes would cumulatively construct an orderly and coherent narrative world. VR is very different because the viewer is free to look anywhere within a 360-degree visual field. This greatly changes the work of VR filmmakers and the creative tasks they face. Alex Hessler, a VR supervisor for Tippett Studio, notes, "We do have a lot of techniques in cinema that we know how to use to steer the viewer, but unfortunately those techniques don't generally work in virtual reality" (Edwards, "Future"). Malte Wagener, the head of Deluxe VR, points out that cinema and VR differ in that in VR, "you don't per se have a single camera and you can't pre-frame a shot and say, 'This is how the audience will look at a scene.' You hand over those reins to the

viewer to a certain extent" (Kadner, "Surveying" 62). Ben Grossmann, of the VR company Magnopus, states, "The hard part is wrangling the audience into looking where you want them to look, in order to catch the part of the story that you want them to catch. You do that by lighting, by sound, by emotional interest—and that language has yet to be codified" (Edwards, "Future")

Indeed, just as the language of VR filmmaking is yet to evolve, it remains unclear to what extent the stylistics of cinema can map onto it. Filmmakers do not control the frame as they did with cinema—viewers can look where they wish, and this is a major part of VR's appeal. As David Bordwell writes, "VR gives with one hand and takes away with the other, so to speak: Greater immersion yields less of the pictorial structuring that's inherent in framing" ("Venice"). Cinema and VR operate with different tool-sets that currently are not fully compatible. Visual effects work in cinema, for example, takes place on flat-screen display monitors, even though computer graphics them-selves are three-dimensional. Rendering operations for cinema convert the volumetric nature of computer graph-ics into the two-dimensional space that cinema requires. Visual effects work and compositing operations for VR films require a translation process to move back and forth between VR and existing toolsets designed for cinema but not for spherical space. Visual effects work on *Invisible*

(2016) required converting the spherical space of the camera's stitched-together video streams into "lat-long" files in which the spherical perspective was unfolded to a 2-D representation, like the printed world maps representing a globe. As the CEO of the effects house working on the film pointed out, "A lot of commonplace compositing operations just plain fail in virtual reality. For example, you can't just blur a lat-long image, because you're not in a linear space where a radius around a single pixel is consistent around the frame" (Edwards, "Dreamsmiths" 85).

To what extent is editing possible in VR space? A VR camera such as the Jaunt captures twenty-four video streams from sixteen cameras mounted around the equator of the Jaunt's spherical housing, with an additional four cameras each on the unit's top and bottom. Each lens captures a 130-degree field of view, and stitching algorithms combine the individual fields of view into one spherical perspective, offering a 360-degree field in which the viewer's gaze may travel in any direction. Changing the coordinates of spherical space with editing does not seem to work in the same manner that continuity cutting does in two-dimensional space. A viewer's gaze may be located anywhere inside spherical space, whereas in cinema, that gaze is isomorphic with the camera's line of sight, which enables shot changes to reliably position a new line of sight that does not disrupt the coordinates

of screen space. Some VR films have experimented with shot changes. *The Mission* (2014) is a seven-minute spherical, stereoscopic video that provides viewers with the VR experience of being inside a World War II battlefield. Its director used some quick cuts in the film and operated with a mobile, handheld camera, flouting the existing assumptions of what is possible in VR filming. *Follow My Lead* (2016) documents the 2016 NBA Finals, providing a VR experience in which viewers seem to be on the court with the players. Multiple cameras covered the action, and in order to cut between them, the filmmakers rotated the spherical space of the incoming shot around its vertical axis so as to align the focal points of the two shots. The default assumption in VR filmmaking, however, tends to be that space should be treated holistically.

Clouds over Sidra (2015) shows how limited editing can coexist with a holistic treatment of space. A VR documentary produced for the United Nations, it depicts life in the Zaatari refugee camp in Jordan, which holds thousands of refugees from the Syrian war. The film places the viewer inside the camp, and its 360-degree spaces enable the viewer to explore the camp in ways that overcome some of the limitations of traditional documentary footage. The details and textures of ordinary life—the way a room looks, the blankets on a bed, the antique nature of an old television—emerge so as to challenge the stereotypical

visual tropes that news footage employs when showing such camps. Instead of melodrama, the film stresses the textures of daily life. A twelve-year-old girl, Sidra, who has lived in the camp for more than a year, becomes a kind of tour guide, escorting the viewer through the camp via her voice-over commentary. The film is composed of fourteen scenes, each consisting of a single shot, and fades swiftly connect one scene to another. The scenes show us the exterior of the camp, Sidra's bedroom and living space, her classroom, a bakery and an internet café, a weight-lifting room for boys, and various places where children hang out with each other. We see them playing and walking to school. Sidra describes each place and what people do there, and she talks about how she feels about living in the camp and her uncertainty about whether she will ever be able to return home. Each scene is long enough that the viewer can explore the space in all directions, although there are primary zones of activity that compete for the viewer's attention. The editing often conjoins scenes so that the chief zones of interest in each scene match up, but there are occasions when this does not occur and sound information, such as a group of children's voices buzzing with excitement, direct the viewer to explore the space to bring them into view. The fades that join scenes are a soft form of editing, like the dissolves that join shots in *Greenland Melting* (Bordwell, "Venice").

Although, as noted, HMDs tend to be physically isolating, numerous commentators have speculated that VR is an effective medium for eliciting empathy because it enables a viewer to existentially inhabit spaces that have emotional salience for the people depicted in a VR film as residing in them. There is some empirical support for this view (Gillath et al.; Kalyanaraman et al.; Chambers and Davis; Gerry). *Clouds over Sidra* was made with the objective of using VR to elicit an empathetic response from viewers regarding Sidra and more generally the thousands of people displaced as refugees. The UN screened the film for diplomats and global decision-makers at the World Economic Forum in Davos and provided smart phones and headsets for them to use in viewing it (Anderson). The cofounder of the film's production company described VR as an "empathy machine," and the goal in showing the film at Davos was to enable influential leaders to virtually walk in Sidra's shoes (Anderson). As the film's codirector Gabo Arora said, "I think a lot of these people, even when they would go into the Zaatari camp or someplace like that, it's with an entourage. I just didn't feel like they were really, truly understanding what it's like to walk in someone else's shoes, and I think that all of them need to" (Anderson).

In this respect, VR may provide an effective new tool for advocacy filmmaking, giving documentary film-

makers a strategic means of eliciting existential empathy. Alejandro Iñárritu's *Carne y Arena* (*Flesh and Sand*, 2017) is a VR installation designed to give form and shape to the memories and experiences of Mexican and Central American immigrants and refugees as they journey to cross the border into the United States. Iñárritu collaborated with the cinematographer Emmanuel Lubezki on what he described as "a semi-fictionalized ethnography" (Benjamin B, "*Carne*"). It is a walk-around VR experience in which the viewer moves around inside a tennis-court-sized enclosure, wearing a headset tethered to the ceiling. The virtual environment is a desert landscape where the viewer meets a group of people trying to cross into the United States when they are accosted by the U.S. Border Patrol. The viewer walks in their path, with them. A writer for *American Cinematographer* described the experience: "Soon a group of some ten Latino immigrants walk into the space. The huddled figures feel real, they have a human presence. And I have a natural inclination to respect their personal space. As I decide to approach one of the immigrants, a helicopter appears above me. The searchlight blinds me, the noise is deafening, and there is a blast of wind. Then a US border patrol drives up in big SUVs, uniformed men come out and order everyone to kneel on the ground. Instinctively, I too kneel on the sand, right next to one of the immigrants" (Benjamin

B, "*Carne*"). Through the VR experience, the viewer joins the immigrants on their journey and is treated with them as an undocumented alien by the border patrol. Virtual and physical sensations are conjoined—the viewer walks shoeless through the VR arena whose floor is covered with sand, giving the desert environment a strong, tactile presence. When the VR experience ends, the viewer exits the hall, passing portraits of the real immigrants, with their biographies, who had been filmed for the VR experience. Also on display are their shoes, which the viewer can pick up and touch. These elements conjoin the real and the virtual, aiming to facilitate the elicitation of empathy using filmic and concrete referents.

Iñárritu said, "VR is all that cinema is not, and vice versa; the frame is gone and the two-dimensional limits are dissolved" (Benjamin B, "*Carne*"). Although the two media may operate differently, in some ways cinema and VR have piggybacked onto each other. Many visual effects artists have moved from cinema into VR to find new challenges. Tippett Studio, for example, was founded by the creature animator Phil Tippett, whose stop-motion puppetry appears in the *Star Wars* films *A New Hope* (1977) and *The Empire Strikes Back* (1980), as well as in numerous other movies. The studio continues to provide visual effects for feature filmmaking but also now works in VR. *Mad God VR (OMG)* (2016) is a stop-motion VR

animation directed by Tippet that moves his analog- and digital-era puppetry into the VR realm. Other indicators of this cross-fertilization are the numerous VR films that are released and marketed in conjunction with Hollywood blockbusters. *Trials on Tatooine* (2016) is a production of ILMxLab, a subsidiary of Lucasfilm and Industrial Light and Magic concentrating on immersive entertainment. Designed for the HTC Vive headset, the film places the viewer on Tatooine, the bleak, desert world where Luke Skywalker was born and that has appeared in five *Star Wars* movies. The narrative of *Trials* is situational—the viewer finds him- or herself on the planet as the *Millennium Falcon* (Han Solo's spaceship) lands in need of some repairs. The viewer helps to complete these as TIE fighters from the Imperial fleet zoom overhead and fire at the *Falcon*. R2-D2 provides the viewer with a lightsaber, which can be used to deflect incoming missiles. The repairs completed, the *Falcon* takes off as Han Solo (who remains off-screen throughout) bids the viewer farewell and good luck.

The narrative situation is greatly enriched by the extensive *Star Wars* mythos in which it is embedded and that has been under continuous elaboration in film and other media for decades. Thus, the *Falcon*, the lightsaber, the planet Tatooine, and the characters Han Solo and R2-D2 need no introduction or elaboration; they arrive

fully formed and resonant with meaning and emotion. The VR experience extends the mythos by providing a visceral experience of scale that goes beyond what the films have been able to show. The vastness of Tatooine is tangibly present when viewers turn their heads, rotating the landscape with parallax changes across the field of view. When the Falcon flies in, it assumes an impressive size and weight, hovering directly above the viewer, who is required to look up in order to study its size. When the TIE fighters attack, instead of watching the actions of a movie character on screen, the viewer can run and hide or duck down and try to evade the attack, can choose how to behave. *Trials on Tatooine* belongs to a burgeoning genre of VR experiences that are tied in to major films. *The Martian* (2015), *Dunkirk* (2017), *Ghost in the Shell* (2017), and *Spiderman: Homecoming* (2017) are among many films that are being marketed with a VR experience.

Although cinema and VR intersect and can overlap, a major difference between them lies in the nature of narrative and how each medium is equipped to handle it. Narratology, the study of narrative, distinguishes two different domains that compose the narrative experience. One is the story itself, the collection of events that make up the narrative. The other is the telling of the story. The two domains do not share a single time frame, which enables the telling, the act of narrative, to reorganize story

events in many ways. These include beginning in medias res, employing flashbacks, occluding or omitting key events, and so on. Narrative contains a sense of pastness, a sense of events already having happened and that the act of narration recalls, recollects, or re-presents. As David Bordwell writes, "there is the sense that the text before us, the play or the film, is the performance of a 'prior' story" (*Narration* 15). In cinema, this means that the viewer of a film is simultaneously inside and outside the story. The mobile point of view, achieved through changing camera positions and editing, moves the viewer through the narrative world, and the duration of the film for two or more hours sustains the viewer's sense of being a part of that world. And yet a simultaneous sense of standing outside the narrative and watching it from some place other than its represented locations is copresent with the sense of immersion.

The two-dimensional nature of cinema, its display on a flat surface, has much to do with this dual mode of perception. The sense of immersion is elicited by numerous factors in cinema, among which are visual depth cues in the image that convey tangible information about three-dimensional space and the positioning of objects within that space. Cinema is able to reproduce some of the depth cues that operate in the real visual world. Real-world cues include occlusion or overlap (near objects

occlude farther objects along a line of sight), relative size (objects appear smaller with increasing distance), height in the visual field or picture plane (farther off looks higher up), aerial perspective (hazing from the atmosphere and a color shift toward blue affect very distant objects), motion perspective (differences in the apparent rate of motion according to distance from the observer), convergence (movement of the eyes toward each other to sight a near object), accommodation (change in the shape of the eye's crystalline lens to focus on a near object), and binocular disparity (differences in the retinal location of an object as found in each eye). Cinema replicates the cues of occlusion, relative size, height in the picture plane, aerial perspective, and motion perspective. Stereoscopic, 3-D cinema also incorporates vergence movements of the eyes and binocular disparity, but their elicitation in cinema diverges from their operation in the natural world because these cues work effectively at very close distances (six feet from the observer or less), whereas camera-to-subject distances and screen-viewing distances in a theater tend to be greater than this. James Cutting and Peter Vishton have shown that the effectiveness of depth cues varies according to viewing distance, and nearly all of the depth cues that conventional (nonstereoscopic) cinema incorporates work effectively at distances greater than that of intimate space.

Thus, the sources of visual information that suggest the
presence of a three-dimensional world on the flat surface
of a theater screen are cues whose efficacy positions the
viewer at some remove from the narrative world. These
are cues that place the viewer outside the spectacle. To the
extent that it looks three-dimensional, it does so based
on visual information that requires the observer to be at
a greater-than-intimate viewing distance. Moreover, the
image is finite; it has borders that the viewer continues to
see during the film. The visual domain of a VR experience
is not bounded or bordered; it encloses the viewer and
flows around her or him and may be responsive to the
viewer's head and hand movements or movement through
place. The viewer can interact with it and is not simulta-
neously inside and outside the experience as in cinema.
Here lies a distinction in the way that each medium han-
dles narrative. In cinema, the sense of the story being
somehow prior to the act of narration is inhospitable to
interactivity. To put this in another way, as Jasper Juul has
written, "There is an inherent conflict between the *now* of
the interaction and the *past* or '*prior*' of the narrative. You
cannot have narration and interactivity at the same time"
(223). Interactivity shifts narrative into a fluid and open-
ended format because the viewer can seem to influence
the course of events. It also increases the sense of bodily
immersion. As Marie-Laure Ryan writes, "While a mind

may conceive a world from the outside, a body always experiences it from the inside. As a relation involving the body, VR's interactivity immerses the user in a world experienced as already in place" (208). The medium seems to disappear, and the viewer "experiences at least the sensation of a direct encounter with reality" (207).

The interactive narrative elements in VR might be understood according to the terms that Christoph Bode has described as characteristics of what he terms "future narratives." These are stories that stage "the fact that the future is a space of yet unrealised potentiality—and by allowing the reader/player to enter situations that fork into different branches and to actually experience that 'what happens next' may well depend upon us, upon our decisions, our actions, our values and motivations. It might therefore be said that these narratives preserve and contain what can be regarded as defining features of future time, namely that it is yet undecided, open, and multiple, and that it has not yet crystallised into actuality" (1).

Alternatively, Henry Jenkins's characterization of narrative in video games might be extended to VR experiences, especially since the compatibility of video games and VR is quite clear. Jenkins understands game designers not as storytellers but as what he calls "narrative architects," who create compelling spaces that the viewer/

player aims to explore, map, or master. It is an environmental form of storytelling, where story flows from predesigned spaces. Environmental storytelling emphasizes spatial exploration rather than plot development. "Environmental storytelling creates the preconditions for an immersive narrative experience in at least one of four ways: spatial stories can evoke pre-existing narrative associations; they can provide a staging ground where narrative events are enacted; they may embed narrative information within their mise-en-scene; or they provide resources for emergent narratives."

Cinema appeals to viewers with its immersive process of narration. Watching a movie, the viewer experiences the pleasure of a well-told story, receives that pleasure from the storyteller. By contrast, storytelling in VR is spatial and environmental; it is an exploratory phenomenon and is future oriented rather than past oriented. ILMxLab's John Gaeta remarks, "We had arrived at this premise that cinema captures a linear story throughout which you are introduced to characters and see fantastic places. But what if you take away the framing of the media and say that these places are actual destinations? Story could flow through these places and you could follow it, but if you chose not to you could still explore and interact with this space" (Edwards, "Dreamsmiths" 95). It is not the case, then, that VR cannot support narrative, as some

people have claimed. But the principles by which narrative operates in VR are different from those of cinema.

Tim Alexander, the visual effects supervisor for new media at ILMxLab, points out, "VR is a new media space and we're all trying to discover what storytelling is within that space. Telling a story in a film versus telling a story in VR is really different, and ultimately [the latter] will probably look nothing like a movie either in form or function" (Kadner, "Surveying" 60). Cinema is not going to go away; the pleasure derived from traditional storytelling is deeply encoded in human history and culture. But cinema's bounded, two-dimensional nature may come to seem increasingly conventional, even anachronistic, in a future when VR seamlessly pervades everyday life, much as the internet does now. Perhaps, should such a future arrive, the pleasures afforded by unidimensional narratives will cede cultural space to those provided by VR's spatial destinations. One thing does seem clear: the expressive properties of cinema are by now thoroughly understood and explored; by contrast, VR is an open horizon on which a digital future beguiles and beckons to viewers.

5

EVERYWHERE AND NOWHERE

In chapter 1, I suggested that numerous continuities exist between the analog and digital eras, understood with regard to the industry's image-making practices and conventions, and in chapter 2, I suggested that "realism" remains a foundational concept orienting the ways that viewers make sense of cinema images and narratives. On the basis of these considerations, it would appear that reports of an analog-digital divide in cinema history have tended to overstate differences between the eras. But let us change our angle of focus now and consider a new context. Doing so will lead us to draw a very different conclusion than was evident in those initial chapters.

With *Dunkirk* (2017), shot on 65mm film, the director Christopher Nolan continued his robust efforts to demonstrate the viability of film as film. Indeed, physical media remain with us but in diminishing ways. At the time of this writing, DVD and Blu-ray remain active home-video formats, and movies continue to be shown

in brick-and-mortar theaters. The theatrical movie audience has remained relatively stable for several decades, with U.S. and Canadian admissions (ticket sales) hovering between one and one and a half billion per year. Cinema (theater) screens increased 8 percent worldwide in 2016 to nearly 164,000, with most of this growth overseas in the Asia Pacific region, but digital screens represent the overwhelming majority, at 93 percent (MPAA). Films screened digitally, of course, are not "film" in a strict sense. They are DCPs, digital cinema packages, consisting of data files, streams of image and sound that can be encrypted and distributed as a hard disk or electronically via satellite or fiber-optic cable.

Instead of examining the image-making practices and storytelling conventions that prevail in analog and digital cinema, as we did in chapters 1 and 2, if we now examine the ways that cinema circulates and the ways that viewers encounter it, we will confront the biggest, most decisive and game-changing effects of the digital era. The most radical alteration has been a direct outcome of cinema's shift away from a material base. Cinema has become data, ones and zeros coded so that the data stream can be played back with a graphical user interface on platforms of various kinds. Data is portable and recombinant. In previous generations, cinema was a place as much as an experience. Moviegoers were "goers." They saw movies

in theaters, and some of those were epically spacious and grand, making the experience like stepping into another reality. Moviegoers also watched films at home on television or on home video, which helped to perpetuate cinema's identity as a physical medium. Now, viewers are connected to the internet and can watch movies on a variety of portable electronic devices, including laptops, tablets, and cell phones. This change has led to generational differences among viewers regarding the medium and the viewing experience. The medium has become ambiguous, tied as it is to numerous display devices, many of which are small and portable. Younger viewers are comfortable with this ambiguity; movies are an experience that is technologically diverse and capable of being encountered in numerous ways, none of which is seen as possessing an inherent, ongoing superiority. A. O. Scott, the film critic for the *New York Times*, has written that young viewers are "platform agnostic, perfectly happy to consume moving pictures wherever they pop up—in the living room, on the laptop, in the car, on the cell phone—without assigning priority among the various forms."

Recently I taught a class on horror movies, and one of the films that we screened and studied was Stanley Kubrick's *The Shining* (1980). One of the students in the class already knew the film and had seen it before, having watched it on his laptop. It was a film that he liked a

lot. When we viewed it in class, however, projected on a large screen in a three-hundred-seat auditorium, he was taken aback at how powerful the movie now seemed and remarked to me that this was a surprise. I replied that the film was meant to be seen big. To me, this seemed like an obvious point, but I do not believe that it was for the student. Platform agnosticism, of the sort that Scott describes, tends to blur the inherent fit between a film and the viewing environment it was designed for.

As Wheeler Winston Dixon points out, film may be dead, but movies are not. As cinema has morphed into data streams played back on an array of viewing devices and in a variety of environments, one huge surprise in this evolution has been the shrinking size of its images. For most of the history of cinema, the emotional power and appeal of movies were tied to the experience of seeing them projected on giant screens in large auditoriums. Movies evolved stylistically to take advantage of the bigger-than-life space of theatrical projection. Filmmakers did not have to rely on close-ups to convey essential story information, and some, such as John Ford, actively eschewed using them. Cameras could frame a scene from a modest distance, showing actors in full-figure shots so that all of their body was visible and they could act with their body instead of standing in place delivering dialogue. While shallow focus proved to be a useful

storytelling tool, moderate- and deep-focus shots could be used for subtle effect. A more leisurely editing pace, compared with today, in which shots might be lengthy, enabled all of these designs to be held on screen so that they might come forward as figurative devices. All of this has become much harder to achieve and less effective as screen size gets smaller. It seems likely that the abundance of close-ups and fast cutting in contemporary cinema is an adjustment to the fact that many, if not most, viewers will be doing the bulk of their viewing on small screens. Once cinema became a theatrical medium, housed in large auditoriums, how many people foresaw that it would eventually go in the other direction, back to its kinetoscope origins as a small-screen experience?

Today cinema has become part of the international trade in data, and it joins many other data streams to form a user's connected, electronic media experience. Numerous factors have driven this transformation, which include the cost savings that digital distribution represents for the studios and their ability to protect copyrighted content by encrypting it. But especially important is the huge growth in mobile data traffic. In 2016, global internet traffic was 1.2 zettabytes, which is equivalent to one billion gigabytes per month (Cisco, "Global"). Although wired devices accounted for 51 percent of global internet traffic, mobile data grew by 63 percent in 2016, with almost

half a billion new devices and connections added. Connection speeds for mobile networks grew more than 300 percent, and mobile video traffic accounted for more than half of total mobile data traffic. Since video consumes a lot of bandwidth, the increase in connection speeds has facilitated the shift to online video consumption. Video traffic is projected to be more than 80 percent of all consumer internet traffic by 2021, and VOD traffic (video on demand, which is often subscription based) is expected to be equivalent to 7.2 billion DVDs per month (Cisco, "VNI Forecast").

This shift to online viewing has reconfigured cinema in numerous ways. I have already mentioned shrinking screen size. Long-established revenue patterns also have been eroded, reflecting changes in the way that audiences encounter films. For nearly two decades, DVD had been a golden goose in the movie business, generating strong revenues that eventually outpaced theatrical box office. But rental and sales of DVD/Blu-ray have declined in recent years, and in 2016, for the first time, subscription streaming ($6.2 billion) outpaced disk sales ($5.4 billion) (Wallenstein). Moreover, VOD outperformed electronic sell-through (movie purchases in electronic formats), leading *Variety*, the industry's trade journal, to conclude that there was now "a dark cloud over the future of ownership of packaged video content, both physical

and digital" (Wallenstein). By 2020, video on demand is projected to account for 71 percent of home-video revenues worldwide (Statista). In 2016, the global VOD market was $16 billion, with more than $9 billion in the United States (Ironpaper).

The evolution of Netflix provides a dramatic illustration of cinema's reconfiguration. It began as a DVD-rental-by-mail business in 1997, shortly after the disk format came on market. The business model was a terrific idea. DVDs were small, slim, and lightweight, making them an easy product to distribute by mail. Getting a disk from Netflix was fast, and originally customers could have four disks out at any one time. You would send one back and get another from a queue of material. Movie lovers compiled long queues of films they wanted to see, and Netflix's catalog was vast, with a trove of old, foreign, and hard-to-find movies. If it was on DVD, Netflix likely had it. Brick-and-mortar DVD rental stores were the losers, and giant chains such as Blockbuster could not compete with Netflix, whose customers never had to leave home to find new movies to watch. Netflix expanded into streaming media in 2007, and in 2013, it began producing original film and television content. In 2016, it released over one hundred films and television series, more than any other television competitor. Over time, the company shifted almost exclusively to internet distribution of electronic

media content. It retained its disk-rental business, but those customers soon found that many movies began disappearing from the catalog. Titles in their queue were vanishing. As things developed, the difference in the number of subscribers for each service said everything about the future of home video. In 2017, Netflix had 104 million subscribers worldwide for its streaming service, compared with 3.7 million subscribers to its DVD rental service. The number of DVD renters had dropped sharply in just a few years—in 2011, there had been 14 million DVD subscribers (Statista).

Netflix now offers far fewer old and foreign films on its streaming service than it did in its glory days as a DVD rent-by-mail operation. Old films are virtually nonexistent on Netflix streaming. As Zach Schonfeld has written, "In the vast world of Netflix streaming, 1960 doesn't exist. There's one movie from 1961 available to watch (the original *Parent Trap*) and one selection from 1959 (*Compulsion*), but not a single film from 1960. It's like it never happened. There aren't any movies from 1963 either. Or 1968, 1955 or 1948. There are no Hitchcock films on Netflix. No classics from Sergio Leone or François Truffaut."

This represents a significant loss for cinema fans who wish to view things other than current, popular releases or made-for-television product. The eclipse of hard media has made old, classic, and foreign films more inaccessible

than they were in the era of VHS and DVD home video. A tremendous number of movies, from all decades, had been released on those formats. In that era, as Todd Van-DerWerff writes, "classic films were everywhere, even if you weren't necessarily looking for them. There were lots of TV channels that simply played old movies in the afternoon, as a way to save money. Video stores were everywhere, and they had shelves devoted to 'the classics.' And in the VHS era, at least, so many movies were released on cassette—even more than have since made it to DVD.... There was a sense of cross-pollination then—of the old and new living somewhat alongside each other." Now, if it is not available for streaming, it does not seem to exist. And as VanDerWerff writes, this makes it harder for novice and new viewers to discover classic cinema.

Streaming presents other problems as well: streaming services tend to make films available on a temporary basis. Companies operating streaming platforms have licensed the rights to present packages of films, and these rights exist for a limited window of time. One can never be sure what is available for viewing at any given time. In the DVD era, by contrast, Netflix owned the disks that it rented to customers. It could continue to offer those disks as long as it pleased. Movies that were released to VHS and DVD/Blu-ray remain available, so long as those formats hold up. Movies released for streaming do not

remain reliably available for viewing. Overall, this makes classic cinema more inaccessible, its treasures somewhat harder to find than in the era of hard media. Streaming services are "walled gardens," presenting a subscription-based barrier to viewers.

At the same time, the streaming market has facilitated the entry of new services offering films aimed at cine-literate viewers. FilmStruck is a joint venture of Turner Classic Movies and The Criterion Collection, offering an assortment of classic and contemporary art-house, independent, foreign, and cult movies. It is a curated operation, which highlights and emphasizes films and filmmakers who are deemed to be notable, important, or worthy. This curating function serves cinema culture in the same ways that film festivals and film journals have long accomplished. The Warner Archive used to offer a stand-alone streaming service of classic Hollywood mov-ies, now available via FilmStruck. Kanopy is another streaming service that offers thousands of films that are important artistically, historically, and culturally. Unlike FilmStruck, which is subscription based, Kanopy is a free service for users belonging to colleges and univer-sities. Roku provides an equipment interface that facili-tates access to numerous streaming channels. Many of these are free, and many offer specialized films. Café Noir emphasizes crime and noir films, while Drive-In Movies

aims at cult, horror, and science fiction B-films, the sort of goofy and semisleazy material that was once the staple of drive-in movie theaters nationwide.

The proliferation of these channels catering to movie lovers suggests that the shrinking market for DVD and Blu-ray is not a death knell for cinema history. Some old, classic, and foreign films remain available for viewers who choose to stream them, though this necessitates carrying multiple subscriptions to the various sites. Of course, much depends on the condition of the films that are presented on streaming services, and some of these are substandard. Many older films have undergone elaborate restorations expressly for release to the Blu-ray market, and it is unclear to what extent this practice will continue in a market where goods are as transient as they are on streaming channels. Prior to the home-video era, movies of any kind that were not in current theatrical release were generally unavailable for viewing. The era of home-video rental and ownership changed this. It was the onset of a golden age of classic movie viewing, but that window now seems to be closing. The growth of streaming and the shrinking market for hard media pose threats to film culture and film history, and movie lovers have found that their choices are diminished relative to the era of hard media.

More than anything else, the eclipse of hard media demonstrates a collapse of the ownership model that

had come to define the home viewing experience since the advent of VHS videotape as a distribution medium near the end of the 1970s. DVD/Blu-ray ownership was tied to traditional interpretations of property rights governing physical objects. The electronic, virtual world of streaming has altered those rights and placed consumers in an increasingly subaltern relationship with media companies. Home video was born in the 1970s with the Sony Betamax recorder and with Matsushita's competing VHS format. Hollywood feared home ownership of motion pictures even as the studios began to exploit the market by releasing catalog titles onto VHS. Videotape recorders (VCRs) enabled consumers to make their own copies of copyrighted films. They could tape them off of broadcast television or make another copy of a VHS tape by hooking two VCRs together. Universal (MCA) and Disney filed suit against Sony, arguing that its recorders facilitated copyright infringement. The case went back and forth for nearly a decade until the Supreme Court ruled in 1984 that home videotaping was a fair-use activity that did not violate copyright. The Court explained, "One may search the Copyright Act in vain for any sign that the elected representatives of the millions of people who watch television every day have made it unlawful to copy a program for later viewing at home, or have enacted a flat prohibition against the sale of machines that make such copying

possible" (qtd. in Harris). How different that philosophy
seems from prevailing judicial opinions today.

An era of personal ownership unprecedented in movie
history had begun—people started building libraries of
favorite movies, first on VHS tape and subsequently on
DVD and Blu-ray—and the studios facilitated this by
selling movies on these media directly to consumers. In
an analog era, copying introduced a generational degra-
dation of picture and sound. VHS copies never looked as
good as their source material. This was not the case with
digital media, and the advent of DVD in 1997 threatened
studios with a loss of control over their products since it
was possible to make perfect digital copies of a DVD. The
studios agreed to support the DVD format provided that
the law protected them in new ways from unauthorized
copying. DVD, therefore, was accompanied by passage
in the United States of the Digital Millennium Copyright
Act (DMCA), which applied to U.S. law the provisions of
two 1996 treaties of the World Intellectual Property Orga-
nization. These provisions criminalized the breaking of
encrypted copyrighted content. It prohibited (a) the dis-
tribution of software or devices that decrypted protected
content or (b) the action of using such devices to decrypt
content. The latter provision became known as the anti-
circumvention provision—it criminalized circumventing
or breaking the encryption scheme that the studios used

to protect DVD and Blu-ray movies from users seeking to copy them onto other devices.

Critics of the DMCA pointed out that it criminalizes many legitimate fair uses of copyrighted works, such as the quoting or copying of images or scenes for use in works of education, criticism, and parody. In order to copy material for these purposes, the encryption scheme has to be broken or circumvented, which was prohibited under the DMCA. Although Hollywood profited massively from home video, the studios never liked the model of ownership on which it rested. If you have legally purchased a DVD, you can give it away, sell it, loan it out, even break or destroy it. This is what ownership means in a world of physical goods. But in the virtual world of streaming media, ownership has changed. As Aaron Perzanowski writes, "The multibillion-dollar digital media marketplace is built, in part, on a lie. Companies like Apple and Amazon entice their customers to 'buy now' and 'own it in HD.' But consumers don't own anything at all, at least according to the license agreements that accompany those sales."

Perzanowski and Chris Jay Hoofnagle, both legal scholars, have examined what people think they own when they click to buy an electronic book, movie, or piece of music from such outlets as iTunes or Amazon. In an empirical study using a sample of more than a thousand people, the

researchers found that most believed that they owned the media material in ways consistent with the ownership of physical goods. But there is no parallel, as Perzanowski and Hoofnagle explain: "A consumer browsing digital movies on the Apple iTunes store, for example, might see an ad inviting them to 'Own It in HD.' What does it mean to Apple and to consumers to 'own' a digital movie? If Apple's terminology draws on a frame established by physical products, that message is inconsistent with the terms for Apple's digital products. The license maintains that consumers may not 'rent, lease, loan, sell, [or] distribute' the movies and music they acquire from iTunes. Likewise, Amazon urges its customers to *Buy Now* for both physical objects and digital files. But Amazon's terms for digital goods reveal similar restrictions for digital goods that do not encumber their physical counterparts." Perzanowski and Hoofnagle suggest that if a "License Now" button were employed by Amazon, Apple, and others selling electronic media content, instead of "Buy Now," people would be less confused about what rights accompany their transaction.

Streaming media content holds great appeal because it is convenient and the cost of a subscription or single rental is relatively inexpensive. When consumers purchase electronic content, Hollywood maintains control over its product by preventing outright ownership.

Instead of ownership, people have licensed the ability to access the content in certain ways and under certain conditions. To the extent that people store their media "purchases" in the cloud, their connection with the material becomes more tenuous. "As high speed mobile data networks matured, sellers encouraged consumers to store media on the provider's cloud network. Since those files may not be stored permanently on a user's device, continued possession and access is less certain. The lack of physical possession means that consumers' access to their purchases is contingent on the cloud service provider. Apple, for example, has removed purchased albums from the iTunes cloud accounts of consumers at the request of copyright holders" (Perzanowski and Hoofnagle).

"Ownership" in the Apple universe ties consumers to Apple's systems and hardware. Content purchased or rented from iTunes must be played on Apple machines using Apple software, and there are limits on the number of machines on which an item can reside. In this way, cloud-based computing offers corporate content creators significant forms of control, and they are accompanied by systems of surveillance and the monitoring of consumer behavior. Locked, encrypted content-control systems—known collectively as digital rights management (DRM)—are widely used by content providers. Consumers purchase licenses that enable them to access

protected files and view them under very narrow terms and conditions; often they must use proprietary platforms to do so, and their behavior is tracked and analyzed. Netflix, for example, maintains an elaborate database of user analytics, which it has generated by tracking users' behavior in very close terms. When you stream a movie from Netflix, the company records how long you watch, when you start and stop, and the scenes and sections of the movie during which you pause or go back to re-view. Netflix connects such user behavior with particular kinds of movie content, so that when it produces its own material—as with the series *House of Cards*—it can shape that material according to what it knows about how people watch and what they like or do not like.

Hollywood has supported an elaborate digital rights authentication and cloud-based storage system, known as Ultra-Violet. It was the creation of a consortium called the Digital Entertainment Content Ecosystem, composed of more than seventy movie studios, retailers, internet service providers, cable television companies, and consumer electronics manufacturers. Consumers have been asked to create an Ultra-Violet account, and when they purchase digital content that is Ultra-Violet compliant, they can add their license for this content to a Digital Rights Locker, a kind of central storage mechanism that enables them to play the movie or other digital content

on a variety of devices that have access to the web: tablets, smart phones, laptops, Blu-ray players, internet TVs. They are not buying physical media but, instead, rights to download or to stream content. All Ultra-Violet digital content uses a common, encrypted file format that is designed to play in all devices used across the system.

The Ultra-Violet terms of use state clearly that all of the content for which users purchase licenses remains the property of the Digital Entertainment Content Ecosystem and that users may not do the things we customarily do with things that we own, namely, loan it out, resell it, or give it away. As with many DRM schemes, the rules of encryption and access create barriers to use that consumers have to negotiate in order to watch a movie they have paid money for. This is true even in the world of hard media. Menu functions enabling users to skip forward are routinely disabled on DVD and Blu-ray, forcing users to watch previews of coming attractions or to submit to the FBI and Homeland Security warnings that these disks carry. Even if you have legally purchased the disk, you are still required to submit to these threats by government agencies to prosecute you should you misbehave with copyrighted material. In a broader context, cumbersome content-control systems that restrict what people can do with material they have paid money for are, arguably, an important factor promoting the very piracy that the

schemes are intended to prevent. One reason that people use BitTorrent to illegally access copyrighted material is so that they may use that material in less restricted ways.

Systems of surveillance and encryption have facil-itated the distribution of copyrighted material on the internet, but this material coexists with a huge amount of copyright-free and user-created material. Indeed, the size and scope of internet-based video traffic is astounding. YouTube, for example, has more than one billion users. More than four billion videos are viewed each day, and three hundred hours of video are uploaded to YouTube every minute (Statistic Brain). A sizable amount of video traffic on the internet also belongs to Hollywood as a part of its ongoing cinema-production activities. Visual effects often are created via the internet. Many production houses that create visual effects are independent contrac-tors. The production firms are scattered throughout the United States, Canada, and Europe. As Mallory Pickett has written in the *New York Times*, "While visual effects' role in movie making is growing, its presence in Holly-wood is shrinking. From 2003 to 2013, at least 21 notable visual-effects companies went out of business, including Digital Domain, which produced the Oscar-winning effects in 'Titanic.'" In their place, tax incentives have lured visual effects production firms to Vancouver, British Columbia, and London. London's Framestore worked on

the effects for *Gravity* (2013), and another London-based firm helped create the digital jungles in *The Jungle Book* (2016). Double Negative in Vancouver helped create the space battles in *Star Trek Beyond* (2016).

Filmmaking of this sort has become geographically dispersed. A director must coordinate the input of scores of technicians, artists, and engineers, based in different locations or regions, who are collaborating to make all the small pieces that will be joined in a composite shot. "The brain directing most of the action may be in one place (usually Los Angeles), but different arms are distributed around the globe, managing various shots, scenes and characters" (Pickett). The internet enables all of this to work, but "the files involved are so huge—a typical four-second shot ranges from 1.2 to 9.6 gigabytes, and an effects-heavy film could easily involve more than 1,000 such shots . . . —that trying to shove them through the Internet is a challenge" (Pickett). Private fiber networks connecting Los Angeles, Vancouver, and London facilitate the transmission of fully rendered frames. Under these conditions, film directing becomes a vastly complicated administrative task.

The huge amount of video traffic on the internet may seem to be weightless, devoid of mass, and ethereal. For consumers, a movie magically appears when they push a button on their smart phone. But, in fact, data is physical

and consumes energy. The international trade in data requires the maintenance of vast server farms consisting of banks of wired servers to store and transmit the global appetite for information and entertainment. Popular culture knows these corporate data centers as "the cloud," and the popular press has presented the rise of so-called cloud-based computing in the rapturous terms that often greet new media. The cloud has become an almost mystical term, connoting ideas of efficiency, cleanliness, green politics, environmental sustainability, purity, and freedom from the material constraints of physical reality. The cloud is where nature, poetry, and the imagination soar high above our material lives, as suggested by graphics visualizing these qualities that can easily be found on the internet. The cloud offers us a virtual world where all things are possible, a realm of transcendence and plenitude.

In fact, however, data centers consume a significant amount of energy. According to U.S. government estimates, "US data centers consumed about 70 billion kilowatt-hours of electricity in 2014, . . . representing 2 percent of the country's total energy consumption" (Sverdlik). This was a relatively small increase after many years of exponential growth. The major corporate data centers have become more efficient at using energy, but this has not been the case for many smaller centers.

Many server farms use diesel generators as backup power sources, producing toxic air emissions, and they consume physical resources in other ways as well. Google opened a major data center in Berkeley County, South Carolina, and faced a standoff with county residents and officials over its plan to draw one and a half million gallons of water per day from an underground aquifer that supplies drinking water to the region (Peterson). Google would use the water to cool its servers in the data center. Nonrenewable fossil fuels (coal, natural gas, petroleum) generated more than half of all electricity in the United States in 2016 (U.S. Energy Information Administration). Coal provides just under one-third of U.S. electricity. Burning coal has been one of the biggest sources of air pollution in the United States, producing acid rain, soot, and smog and making a significant contribution to global warming. Cloud computing—and the myriad forms of mobile culture consumption that it promotes—generates an intensive demand for electricity, which, in its present form, is a dirty source of energy. All predictions indicate that data-center demand will increase as more users come online, particularly in areas such as China, India, and South America. Clean, renewable energy sources are needed to support the ever-increasing demand for data. At present, cloud computing threatens to take us farther down a path of unsustainable energy consumption.

In this respect, the ecosystem on which cloud computing rests is fragile, and so, too, are the data, with regard to the digital media and formats that house them. As Wheeler Winston Dixon points out, "cinema history is so vast that it can never be encompassed, no matter how assiduously one might try, and images are disintegrating or being erased faster than we can possibly archive them." Cinema's shift to digital media has made its images and films more unstable and potentially short-lived than they were on the physical medium of a film strip. Digital formats are poor archival media because they present inherent problems for the access and preservation of material. The Science and Technology Council of the Academy of Motion Picture Arts and Science referred to this issue in 2007 as "the digital dilemma." The council wrote, "The goal of a digital preservation system is that the information it contains remain accessible to users over a long period of time. The key problem in the design of such systems is that the period during which such assets need to be accessible is very long—much longer than the lifetime of individual storage media, hardware and software components, and the formats in which the information is encoded. . . . Today, no media, hardware or software exists that can reasonably assure long-term accessibility to digital assets" (13). Digital technology changes rapidly, and

digital-cinema data are stored on physical media that last a few decades instead of the century or more that is desirable from the standpoint of preservation. "Digital assets are hard to maintain long-term because media, hardware and software can all become obsolete. This is commonly caused by the evolutionary loss of compatibility between data in the archive and the software applications that originally created the data. Sometimes proprietary formats in an archive are simply abandoned when a company goes out of business" (Science and Technology Council). Thus, any digital materials in storage require continual upgrading.

The vast trove of digital movies, books, sounds, and music that seems so essential to modern life in the industrial world is threatened by a short road to disintegration and disappearance. The connection of photography and mortality is one that philosophers and critics have often remarked on (Barthes; Sontag). Old photographs are pictures of dead people. They show people and places that no longer exist. Eventually the photograph, too, will fade, but photographic film has proven itself to be an excellent archival medium. Properly stored, its images can be preserved. No such assurance presently exists with digital media, which means that one's visible memories of the past, indeed, of one's life, if encoded digitally, will be more transient than if they had been stored on film. Digital

modes leave the visual culture that movies represent relatively unprotected.

So things are gained and things are lost. As a medium of moving images, cinema is not in peril of vanishing because the experience of moving images has been an enduring human desire. In this respect, cinema in the digital era establishes clear connections and continuities with its analog counterpart. Cinema remains a vibrant and popular medium, providing audiences with the kinds of pleasures that movies have long claimed as their special province. Far from diminishing these pleasures, the digital toolbox enables filmmakers to intensify the projective illusions that underlie them. As has been the case throughout cinema history, filmmaking intelligence counts for more and carries greater weight than does a particular tool of filmmaking, whether it is analog or digital. Though cinema has left its analog apparatus behind, viewers continue to care deeply about movies, and the medium remains adept at rousing passions and controversies. Cinema's alliance with photographically based notions of truth has carried through into the digital era, and cameras today have become more pervasive and extensive in the ways they are being used to document events both topical and mundane.

And yet a transition has occurred. Cinema is no longer a stand-alone medium with a distinct identity and place

of consumption. In fact, it can be difficult to say what it now is and where it is. It is everywhere and nowhere. Many young people today have never known life without the internet. Far from having a unique presence, movies are embedded in webpages, streamed to tablets, shared on smart phones; they are a pervasive but also a subliminal presence, one element in the ongoing electronic hum of mediated attention in today's world. When cinema was a physical medium, its boundaries and borders were clear. Now it has become a virtual medium, translated into data and the international trade in data and the policies of control and surveillance that accompany this trade. It is more difficult now to find cinema or to identify it. It has become protean and recombinant, fulfilling its destiny as a stream of binary numbers traveling the global circuitry that defines much of life as we know it today.

ACKNOWLEDGMENTS

Many thanks to the great team of Wheeler Winston Dixon, Gwendolyn Foster, and Leslie Mitchner for inviting me to contribute this volume to their Quick Takes series. Writing the book provided me with an opportunity to update my previous work on visual effects and to explore other important attributes of cinema in the digital age. Wheeler and Gwendolyn moved things along with dispatch and provided excellent feedback on the manuscript. It is always a pleasure working with Leslie, whose passion for books and for publishing helps to make everything work better and is what a writer really wants.

A big thank you to Susan, whose good cheer and love of movies was exactly the right mix for this excursion.

FURTHER READING

Alter, Adam. *Irresistible: The Rise of Addictive Technology and the Business of Keeping Us Hooked.* New York: Penguin, 2017.

Aufderheide, Patricia, and Peter Jaszi. *Reclaiming Fair Use: How to Put the Balance Back in Copyright.* Chicago: U of Chicago P, 2011.

Benson-Allott, Caetlin. *Killer Tapes and Shattered Screens: Video Spectatorship from VHS to File Sharing.* Berkeley: U of California P, 2013.

Bode, Lisa. *Making Believe: Screen Performance and Special Effects in Popular Cinema.* New Brunswick, NJ: Rutgers UP, 2017.

Chan, Melanie. *Virtual Reality: Representations in Contemporary Media.* New York: Bloomsbury Academic, 2015.

Mathias, Harry. *The Death and Rebirth of Cinema: Mastering the Art of Cinematography in the Digital Cinema Age.* Cardiff, CA: Waterfront Digital, 2015.

McClean, Shilo T. *Digital Storytelling: The Narrative Power of Visual Effects in Film.* Cambridge, MA: MIT P, 2007.

Meyrowitz, Joshua. *No Sense of Place: The Impact of Electronic Media on Social Behavior.* New York: Oxford UP, 1986.

Murray, Janet. *Hamlet on the Holodeck: The Future of Narrative in Cyberspace.* Cambridge, MA: MIT P, 2017.

‌

North, Dan. *Performing Illusions: Cinema, Special Effects and the Virtual Actor*. New York: Wallflower, 2008.

Prince, Stephen. *Digital Visual Effects in Cinema: The Seduction of Reality*. New Brunswick, NJ: Rutgers UP, 2012.

Rickitt, Richard. *Special Effects: The History and Technique*. New York: Billboard Books, 2007.

Rubin, Michael. *Droidmaker: George Lucas and the Digital Revolution*. Gainesville, FL: Triad, 2006.

Ryan, Marie-Laure. *Narrative as Virtual Reality 2: Revisiting Immersion and Interactivity in Literature and Electronic Media*. Baltimore: Johns Hopkins UP, 2015.

Turner, George E., ed. *The ASC Treasury of Visual Effects*. Hollywood, CA: ASC, 1983.

Vaz, Mark Cotta, and Patricia Rose Duignan. *Industrial Light and Magic: Into the Digital Realm*. New York: Del Rey, 1996.

Whissel, Kristen. *Spectacular Digital Effects: CGI and Contemporary Cinema*. Durham, NC: Duke UP, 2014.

WORKS CITED

Allen, Richard. *Projecting Illusion: Film Spectatorship and the Impression of Reality*. New York: Cambridge UP, 1995.

Anderson, Mark. "Can Tearjerker Virtual Reality Movies Tempt Donors to Give More Aid?" *Guardian* 31 Dec. 2015. Web. 10 Aug. 2017. www.theguardian.com/global -development/2015/dec/31/virtual-reality-movies-aid -humanitarian-assistance-united-nations.

B, Benjamin. "*Carne y Arena* Part 1—VR by Alejandro G. Iñárritu with Emmanuel Lubezki, ASC, AMC." *American Cinematographer Blog* 30 June 2017. Web. 14 July 2017. https://ascmag.com/blog/the-film-book/carne-y-arena -vr-masterpiece-innaritu-lubezki.

———. "Rebel Assault." *American Cinematographer* Feb. 2017: 30–53.

Barnes, Brooks. "Coming Soon to AMC Theaters: Virtual Reality Experiences." *New York Times* 26 Sept. 2017. Web. www.nytimes.com/2017/09/26/business/media/ amc-theaters-virtual-reality.html?rref=collection% 2Fsectioncollection%2Fmovies&action=click&content Collection=movies®ion=rank&module=package &version=highlights&contentPlacement=6&pgtype= sectionfront.

Barthes, Roland. *Camera Lucida: Reflections on Photography.*
 Trans. Richard Howard. New York: Hill and Wang, 1981.

Bazin, André. *What Is Cinema?* Vol. 1. Ed. and Trans. Hugh
 Gray. Berkeley: U of California P, 1967.

Bode, Christoph. "The Theory and Poetics of Future Nar-
 ratives: A Narrative." *Future Narratives: Theory, Poetics,
 and Media-Historical Moment.* By Christoph Bode and
 Rainer Dietrich. Berlin: De Gruyter, 2013. 1–108.

Bode, Lisa. *Making Believe: Screen Performance and Special
 Effects in Popular Cinema.* New Brunswick, NJ: Rutgers
 UP, 2017.

Bordwell, David. *Narration in the Fiction Film.* Madison: U
 of Wisconsin P, 1985.

———. "Venice 2017: Sensory Saturday; or, What Puts the
 Virtual in VR?" *Observation on Film Art* 3 Sept. 2017.
 Web. www.davidbordwell.net/blog/2017/09/03/venice
 -2017-sensory-saturday-or-what-puts-the-virtual-in-vr/.

Bosley, Rachel K. "Worlds Apart." *American Cinematogra-
 pher* Jan. 2017: 38–55.

Bousquet, Michele. *Physics for Animators.* Boca Raton, FL:
 Taylor and Francis, 2016. Web. http://proquest.safari
 booksonline.com.ezproxy.lib.vt.edu/book/animation
 -and-3d/9781135016531/introduction/intro_xhtml.

Bukatman, Scott. *Matters of Gravity: Special Effects and
 Supermen in the 20th Century.* Durham, NC: Duke UP,
 2003.

———. "Why I Hate Superhero Movies." *Cinema Journal*
 50.3 (2011): 118–22.

Cameron, James. Remarks in *Side by Side.* Dir. Christopher
 Kenneally. Company Films, 2012. Film.

Carroll, Noel. *Engaging the Moving Image*. New Haven, CT: Yale UP, 2003.

———. *Philosophical Problems of Classical Film Theory*. Princeton, NJ: Princeton UP, 1998.

Chambers, J. R., and M. H. Davis. "The Role of the Self in Perspective-Taking and Empathy: Ease of Self-Stimulation as a Heuristic for Inferring Empathetic Feelings." *Social Cognition* 30.2 (2012): 153–80.

Chesney, Robert, and Danielle Citron. "Deep Fakes: A Looming Crisis for National Security, Democracy and Privacy?" *Lawfare* 21 Feb. 2018. Web. www.lawfareblog .com/deep-fakes-looming-crisis-national-security -democracy-and-privacy.

Cisco. "VNI Forecast and Methodology, 2016–2021." 6 June 2017. Web. www.cisco.com/c/en/us/solutions/ service-provider/visual-networking-index-vni/index .html.

———. "Global Mobile Data Traffic Forecast Update, 2016–2021." 7 Feb. 2017. Web. www.cisco.com/c/en/us/ solutions/collateral/service-provider/visual-networking -index-vni/mobile-white-paper-c11-520862.html.

Crary, Jonathan. *Techniques of the Observer: On Vision and Modernity in the Nineteenth Century*. Cambridge, MA: MIT P, 1992.

Cubitt, Sean. *The Cinema Effect*. Cambridge, MA: MIT P, 2004.

Cutting, James E., and Peter M. Vishton. "Perceiving Layout and Knowing Distances: The Integration, Relative Potency, and Contextual Use of Different Information about Depth." *Perception of Space and Motion*. Ed.

William Epstein and Sheena Rogers. New York: Academic, 1995. 69–117.

Darley, Andrew. *Visual Digital Culture: Surface Play and Spectacle in New Media Games*. London: Routledge, 2000.

Dixon, Wheeler Winston. "Vanishing Point: The Last Days of Film." *Senses of Cinema* May 2007. Web. http://senses ofcinema.com/2007/feature-articles/last-days-film/.

Duncan, Jody. "At the Barricade." *Cinefex* 133 (Apr. 2013): 12–25.

———. "In a Mirror Darkly." *Cinefex* 150 (Dec. 2016): 68–92.

———. "Into the Wild." *Cinefex* 145 (Feb. 2016): 86–104.

———, ed. "State of the Art: A Cinefex 25th Anniversary Forum." *Cinefex* 100 (Jan. 2005).

Ebert, Roger. "*Spider-Man*." *Chicago Sun-Times* 3 May 2002. Web. 18 Aug. 2017. www.rogerebert.com/reviews/spider-man-2002.

Edwards, Graham. "Dark Materials." *Cinefex* 153 (June 2017): 12–32.

———. "The Dreamsmiths Unleashed. *Cinefex* 151 (Feb. 2017): 80–98.

———. "Explosive Cocktail." *Cinefex* 145 (Feb. 2016): 12–39.

———. "The Future of VR: A Roundtable Discussion." *Cinefex Blog* 8 May 2017. Web. 24 July 2017. http://cinefex.com/blog/future-of-vr-roundtable-discussion/.

———. "A Lonely God." *Cinefex* 152 (Apr. 2017): 58–82.

———. "Love in a Dangerous Time." *Cinefex* 150 (Dec. 2016): 96–119.

———. "Visual Effects—Art or Science?" *Cinefex Blog* 25 Nov. 2014. Web. 6 July 2017. http://cinefex.com/blog/art-science/.

Fincher, David. "*The Curious Case of Benjamin Button*: A Conversation with Director David Fincher." *Set Décor* Summer–Fall 2008: 63.

Fish, Andrew. "At the Helm." *American Cinematographer* Feb. 2016: 42–43.

Flückiger, Barbara. *Visual Effects: Filmbilder aus dem Computer*. Marburg, Germany: Schüren, 2010.

Fordham, Joe. "Extra-Vehicular Activity." *Cinefex* 136 (Jan. 2014): 42–75.

Fox, Jesse David. "What the Critics Are Saying about *The Hobbit*'s High Frame Rate." *Vulture* 14 Dec. 2012. Web. 16 Aug. 2017. www.vulture.com/2012/12/critics-on-the -hobbits-high-frame-rate.html.

Gerry, Lynda Joy. "Paint with Me: Stimulating Creativity and Empathy While Painting with a Painter in Virtual Reality." *IEEE Transactions on Visualization and Computer Graphics* 23.4 (2007): 1398–1406. Web. 25 July 2017. https://ieeexplore.ieee.org/document/7829415/.

Gibson, J. J. *Reasons for Realism: Selected Essays of James J. Gibson*. Metuchen, NJ: Lawrence Erlbaum, 1982.

Gillath, Omri, Cade McCall, Phillip R. Shaver, and Jim Blascovich. "What Can Virtual Reality Teach Us about Prosocial Tendencies in Real and Virtual Environments?" *Media Psychology* 11 (2008): 259–82. Web. 7 July 2017. www.tandfonline.com/doi/abs/10.1080/ 15213260801906489.

Goldman, Michael. "Left for Dead." *American Cinematographer* Jan. 2016: 36–53.

———. "Love and War." *American Cinematographer* Dec. 2016: 50–63.

Goldman, Michael. "With Friends Like These . . ." *American Cinematographer* Oct. 2010: 28–41.

Gourevitch, Philip, and Errol Morris. *Standard Operating Procedure.* New York: Penguin, 2008.

Grau, Arthur. *Virtual Art: From Illusion to Immersion.* Trans. Gloria Custance. Cambridge, MA: MIT P, 2003.

Griffiths, Alison. *Shivers down Your Spine: Cinema, Museums, and the Immersive View.* New York: Columbia UP, 2008.

Gutierrez, Mario A., Frederic Vexo, and Daniel Thalmann. *Stepping into Virtual Reality.* London: Springer-Verlag, 2008.

Harris, Paul. "Supreme Court O.K.'s Home Taping." *Variety* 18 Jan. 1984: 1, 109.

Holben, Jay. "A Date with Destiny." *American Cinematographer* Dec. 2016: 74–82.

Ironpaper. "Video on Demand Statistics and Trends." Nov. 2016. Web. www.ironpaper.com/webintel/articles/video-demand-statistics-trends/.

Jenkins, Henry. "Game Design as Narrative Architecture." *First Person: New Media as Story, Performance, and Game.* Ed. Noah Wardrip-Fruin and Pat Harrigan. Cambridge, MA: MIT P, 2004. 118–30. Web. 29 July 2017. http://homes.lmc.gatech.edu/~bogost/courses/spring07/lcc3710/readings/jenkins_game-design.pdf.

Juul, Jesper. "Games Telling Stories?" *Handbook of Computer Game Studies.* Ed. Joost Raessens and Jeffrey Goldstein. Cambridge, MA: MIT P, 2005: 219–26.

Kadner, Noah. "Blurring the Line." *American Cinematographer* Feb. 2016: 78–85.

———. "Surveying the Virtual World." *American Cinematographer* Mar. 2017: 56–62.

Kalyanaraman, S. S., D. L. Penn, J. D. Ivory, and A. Judge. "The Virtual Doppelganger: Effects of a Virtual Reality Simulator on Perceptions of Schizophrenia." *Journal of Nervous and Mental Disorders* 198.6 (2010): 437–43.

King, Geoff. *Spectacular Narratives: Hollywood in the Age of the Blockbuster*. New York: I. B. Tauris, 2000.

Kuhn, Annette. Introduction to *Alien Zone II: The Spaces of Science Fiction Cinema*. Ed. Annette Kuhn. London: Verso, 1999. 1–8.

Landay, Lori. "The Mirror of Performance: Kinaesthetics, Subjectivity, and the Body in Film, Television and Virtual Worlds." *Cinema Journal* 51.3 (2012): 129–36.

Lebo, Harlan. *Casablanca: Behind the Scenes*. New York: Simon and Schuster, 1992.

Lewis, Jon. *The End of Cinema as We Know It*. New York: NYU P, 2001.

Mandelbrot, Benoit B. *The Fractal Geometry of Nature*. New York: W. H. Freeman, 1983.

Manovich, Lev. *The Language of New Media*. Cambridge, MA: MIT P, 2001.

McClean, Shilo T. *Digital Storytelling: The Narrative Power of Visual Effects in Film*. Cambridge, MA: MIT P, 2007.

Melson, Tom. "Can't See the Jungle for the Trees." *ACM SIGGRAPH '16 Talks* 24–28 July 2016. Web. 24 Apr. 2017. https://dl.acm.org/citation.cfm?doid=2897839.2927429.

Milne, Andy, Mark McLaughlin, Rasmus Tamstorf, Alexey Stomakhin, Nicholas Burkard, Mitch Counsell, Jesus Canal, David Komorowski, and Evan Goldberg.

"Flesh, Flab, and Fascia Simulation on *Zootopia*." *ACM SIGGRAPH '16 Talks* 24–28 July 2016. Web. 22 Apr. 2017. https://dl.acm.org/citation.cfm?doid=2897839.2927390.

MPAA (Motion Picture Association of America). *MPAA Theatrical Market Statistics 2016*. Web. 18 Aug. 2017. www.mpaa.org/wp-content/uploads/2017/03/MPAA -Theatrical-Market-Statistics-2016_Final-1.pdf.

Neuman, Robert. "*Bolt 3D*: A Case Study." *Proceedings of SPIE* 7237 (Feb. 2009). Web. 8 Aug. 2017. https://pdfs .semanticscholar.org/47a0/ef7d0c4f462f2ba385a578c8b 8c27c2a5c42.pdf.

Noll, Michael. "The Digital Computer as a Creative Medium." *IEEE Spectrum* 4.10 (1967): 90.

North, Dan. *Performing Illusions: Cinema, Special Effects, and the Virtual Actor*. New York: Wallflower, 2008.

Nowrouzezahrai, Derek, Jared Johnson, Andrew Selle, Dylan Lacewell, Michael Kaschalk, and Wojciech Jarosz. "A Programmable System for Artistic Volumetric Lighting." *ACM Transactions on Graphics* 30.4 (2011): 1–8.

Orland, Kyle. "Doom Co-creator John Romero Skeptical of Virtual Reality Fad." *Ars Technica* 25 July 2014. Web. 8 Sept. 2017. https://arstechnica.com/gaming/2014/07/ doom-co-creator-john-romero-skeptical-of-virtual -reality-fad/.

———. "Facebook Purchases VR Headset-Maker Oculus for \$2 Billion." *Ars Technica* 25 Mar. 2014. Web. 8 Aug. 2017. https://arstechnica.com/gaming/2014/03/facebook -purchases-vr-headset-maker-oculus-for-2-billion/.

Paci, Viva. "The Attraction of the Intelligent Eye: Obsessions with the Vision Machine in Early Film Theories."

The Cinema of Attractions Reloaded. Ed. Wanda Strauven. Amsterdam: Amsterdam UP, 2006. 121–138.

Perzanowski, Aaron. "Ownership and Deception in the Digital Marketplace." *Slate* 18 Oct. 2016. Web. www.slate .com/articles/technology/future_tense/2016/10/how_ consumers_misunderstand_buy_now_buttons.html.

Perzanowski, Aaron, and Chris Jay Hoofnagle. "What We Buy When We Buy Now." *University of Pennsylvania Law Review* 315 (2017). Web. http://scholarship.law.upenn .edu/penn_law_review/vol165/iss2/2/.

Peterson, Bo. "Google's Controversial Groundwater Withdrawal Sparks Question of Who Owns South Carolina Water." *Post and Courier* 22 Apr. 2017. Web. www.postand courier.com/news/google-s-controversial-groundwater -withdrawal-sparks-question-of-who-owns/article_ bed9179c-1baa-11e7-983e-03d6b33a01e7.html.

Pickett, Mallory. "Why Hollywood's Most Thrilling Scenes Are Now Orchestrated Thousands of Miles Away." *New York Times Magazine* 4 May 2017. Web. www.nytimes .com/2017/05/04/magazine/why-hollywoods-most -thrilling-scenes-are-now-orchestrated-thousands-of -miles-away.html.

Pierson, Michele. *Special Effects: Still in Search of Wonder.* New York: Columbia UP, 2002.

Plait, Phil. "Bad Astronomy Movie Review: *Gravity*." *Slate* 4 Oct. 2013. Web. www.slate.com/blogs/bad_astronomy/ 2013/10/04/ba_movie_review_gravity.html.

Plantinga, Carl. "Folk Psychology for Film Critics and Scholars." *Projections: The Journal for Movies and Mind* 5.2 (2011): 26–50.

Prince, Stephen. *Digital Visual Effects in Cinema: The Seduc-
tion of Reality*. New Brunswick, NJ: Rutgers UP, 2012.

———. "True Lies: Perceptual Realism, Digital Images and
Film Theory." *Film Quarterly* 49.2 (2006): 27–37.

Purse, Lisa. *Digital Imaging in Popular Culture*. Edinburgh:
Edinburgh UP, 2013.

Reitsma, Paul S. A., James Andrews, and Nancy S. Pollard.
"Effect of Character Animacy and Preparatory Motion
on Perceptual Magnitude of Errors in Ballistic Motion."
Eurographics 27.2 (2008): 201–10.

Reitsma, Paul S. A., and Nancy S. Pollard. "Perceptual
Metrics for Character Animation: Sensitivity to Errors
in Ballistic Motion." *ACM Transactions on Graphics* 22.3
(2003): 537–42.

Rodowick, David. *The Virtual Life of Film*. Cambridge:
Cambridge UP, 2007.

Ryan, Marie-Laure. *Narrative as Virtual Reality 2: Revisiting
Immersion and Interactivity in Literature and Electronic
Media*. Baltimore: Johns Hopkins UP, 2015.

Schmidt, Thorsten-Walther, Fabio Pellacini, Derek
Nowrouzezahrai, Wojciech Jarosz, and Carsten Dachs-
bacher. "State of the Art in Artistic Editing of Appear-
ance, Lighting and Material." *Computer Graphics Forum*
35.1 (2016): 216–33.

Schonfeld, Zach. "Netflix, Streaming Video, and the Slow
Death of the Classic Film." *Newsweek* 15 Sept. 2017. Web.
www.newsweek.com/2017/09/22/netflix-streaming
-movies-classics-664512.html.

Schwank, Alexander, Callum James James, and Tony Mici-
lotta. "The Trees of *The Jungle Book*." *ACM SIGGRAPH*

'16 Talks 24–28 July 2016. Web. 25 Apr. 2017. https://
 dl.acm.org/citation.cfm?doid=2897839.2927428.

Science and Technology Council, Motion Picture Associa-
 tion of America. *The Digital Dilemma: Strategic Issues in
 Archiving and Accessing Digital Motion Picture Materials.*
 2007. Web. www.oscars.org/science-technology/sci
 -tech-projects/digital-dilemma.

Scott, A. O. "And You'll Be a Moviegoer My Son." *New York
 Times* 5 Jan. 2007: B1.

Set Decor Online. "Star Trek: Into Darkness." Aug. 2013. Web.
 16 Aug. 2017. www.setdecorators.org/?art=film_decor_
 features&SHOW=SetDecor_Film_Star_Trek.

Shapiro, Ari, and Sung-Hee Lee. "Practical Character
 Physics for Animators." *IEEE Computer Graphics and
 Applications* July–Aug. 2011: 45–55.

Snow, Ben. "Terminators and Iron Men: Image-Based
 Lighting and Physical Shading at ILM." *SIGGRAPH* 2010
 Course. Web. 30 July 2017. http://renderwonk.com/
 publications/s2010-shading-course/snow/sigg2010_
 physhadcourse_ILM.pdf.

Sontag, Susan. *On Photography.* New York: Noonday, 1989.

Stasukevich, Iain. "A Mid-century Affair." *American Cinema-
 tographer* Dec. 2015: 52–63.

Statista. "Number of Netflix Streaming Subscribers
 Worldwide from Third Quarter 2011 to Second Quarter
 2017 (in Millions)." 2017. Web. www.statista.com/
 statistics/250934/quarterly-number-of-netflix-streaming
 -subscribers-worldwide/.

Statistic Brain. "YouTube Company Statistics." Web. 15 Aug.
 2017. www.statisticbrain.com/youtube-statistics/.

Sterner, Tor. "Applications of Advanced Physics in Visual Effects." Master's thesis, UMEA University, Sweden, 9 Sept. 2011.

Stump, David. "Seeing the Light in *Life*." *American Cinematographer* Aug. 2016: 74–77.

Sverdlik, Yevgeniy. "Here's How Much Energy All US Data Centers Consume." Data Center Knowledge 27 June 2016. Web. www.datacenterknowledge.com/archives/2016/06/27/heres-how-much-energy-all-us-data-centers-consume.

Thompson, Patricia. "Times of Strife." *American Cinematographer* Feb. 2015: 42–53.

U.S. Energy Information Administration. "FAQ: What Is U.S. Electricity Generation by Energy Source?" Web. 18 Apr. 2017. www.eia.gov/tools/faqs/faq.php?id=427&t=3.

VanDerWerff, Todd. "The Age of Streaming Is Killing Classic Film: Can Turner Classic Movies Be Its Salvation?" *Vox* 19 Oct. 2016. Web. www.vox.com/culture/2016/10/19/13314670/tcm-turner-classic-movies-film.

Wallenstein, Andrew. "Home Entertainment 2016 Figures: Streaming Eclipses Disc Sales for the First Time." *Variety* 6 Jan. 2017. Web. http://variety.com/2017/digital/news/home-entertainment-2016-figures-streaming-eclipses-disc-sales-for-the-first-time-1201954154/.

Williams, David E. "Cold Case File." *American Cinematographer* Apr. 2007: 32–51.

Witmer, Jon D. "Force Perspective. *American Cinematographer* Feb. 2016: 66–77.

Wollen, Peter. *Signs and Meaning in the Cinema*. Bloomington: Indiana UP, 1976.

Wood, Aylish. "Timespaces in Spectacular Cinema: Crossing the Great Divide of Spectacle versus Narrative." *Screen* 43.4 (2002): 370–86.

INDEX